CW00434165

LIVERPOOL
THROUGH TIME
Daniel K. Longman

AMBERLEY

Thanks to
Liverpool Record Office
Keith Samuels
Dr Damian Dooey
Ian Loughlin

First published 2019

Amberley Publishing
The Hill, Stroud
Gloucestershire, GL5 4EP

www.amberley-books.com

Copyright © Daniel K. Longman, 2019

The right of Daniel K. Longman to be identified
as the Author of this work has been asserted in
accordance with the Copyrights, Designs and
Patents Act 1988.

ISBN 978 1 4456 5326 6 (print)
ISBN 978 1 4456 5327 3 (ebook)

All rights reserved. No part of this book may be
reprinted or reproduced or utilised in any form
or by any electronic, mechanical or other means,
now known or hereafter invented, including
photocopying and recording, or in any information
storage or retrieval system, without the permission
in writing from the Publishers.

British Library Cataloguing in Publication Data.
A catalogue record for this book is available from
the British Library.

Typeset in 10pt on 13pt Celeste.
Typesetting by Aura Technology and Software
Services, India. Printed in the UK.

Introduction

Liverpool has grown exponentially in recent times and many parts of the city have become unrecognisable to how they appeared just a generation ago. Progress is, by its very definition, a concept to welcome, but sometimes our unstoppable steps into the future can trample certain aspects of the past that should otherwise come with us.

Societies throughout history have been forced to make decisions on how they wish to shape their environment. Our Victorian ancestors, who undoubtedly had an eye for their own version of beauty, nevertheless oversaw the demolition and questionable intervention of many splendid buildings designed by their own long-lost predecessors in the name of improvement.

Yet rarely is it a question of pure aesthetics. Economic concerns are by far the most dominant factors when it comes to development. To survive, a building must ultimately be able to pay its way and serve a purpose. When a building becomes a liability, it takes deep pockets and a charitable mindset to allow such a property to continue to produce a deficit, and most buildings do not benefit from inexhaustibly funded owners.

Often change is forced upon us. Wartime bombing and determined acts of enemy obliteration leave us with little choice but to clear away the rubble and start anew. Liverpool suffered significant damage during the Second World War and many of its streets were left scarred by the actions of aerial bombing raids. Today many of these locations can be spotted thanks to the insertion of unusual additions within the streetscape, or even remain unoccupied.

However, once a building is gone it can never truly be returned to any authentic degree. It can, of course, be replicated and appear similar, but its inherent qualities and heritage are lost forever. In such circumstances it is better to construct afresh and create something new, honest and of its time.

Liverpool's cityscape is now an assortment of rich architectural edifices representing hundreds of years of progress and reactions to the varied economic and societal pressures we have faced. It can be tempting to look back and cast scorn at authorities who have overseen the loss of some of our once wonderful buildings, but the question

to retain or demolish is seldom so simple, and twenty-first-century hindsight is a wonderful gift.

In *Liverpool Through Time* I present to you just a small photographic selection of buildings, streets and vistas from in and around the city centre and showcase them alongside their more modern counterparts. It is not possible to include every lost street, structure or business that Liverpool once enjoyed, and the city has altered to such an extent that some historic locations are no longer accessible for worthy comparisons. Despite these hinderances it's clear that the city boasts a healthy blend of the old and new, the better and the worse, and that Liverpool, through time, will continue to grow, adapt and build in the centuries to come.

Every effort has been made to trace and obtain permission to reproduce historical material. If any material has been used without the correct acknowledgement we apologise and will make corrections at the first opportunity.

<div align="right">Daniel K. Longman</div>

The Shakespeare Theatre
Designed by local architect
J. H. Havelock Sutton and situated
in Fraser Street, the Shakespeare
Theatre put on its first
performances in 1888 and had a
capacity for over 3,500 patrons.
Its impressive foyer was panelled
with beautifully carved Dantric
oak representing scenes and
characters from Shakespeare's
plays. The theatre enjoyed an
array of modern installations
including electric lighting,
sprinklers and even a form of
central heating.

The theatre suffered several
financial setbacks over the
course of its existence and was
revived under various owners.
It became the Pigalle Theatre
Club and the New Shakespeare
in the 1950s (the latter under
the directorship of the esteemed
actor Sam Wanamaker), the
Shakespeare Club and the
Shakespeare Casino Club in
the 1960s. A terrible fire tore
through the theatre in the winter
of 1963, which saw flames
shoot up through the building's
domed ceiling, just two weeks
after a major refurbishment. As
the Shakespeare Show Bar, the
building finally closed its doors
forever after another disastrous
blaze ruined the property
in 1976.

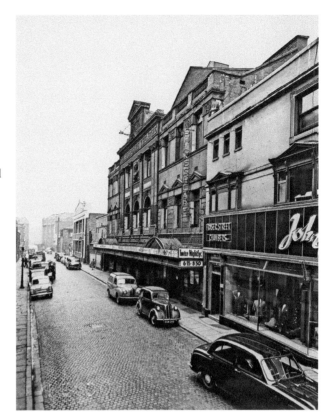

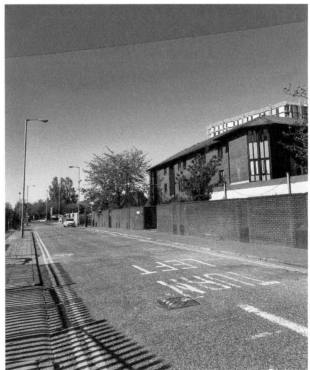

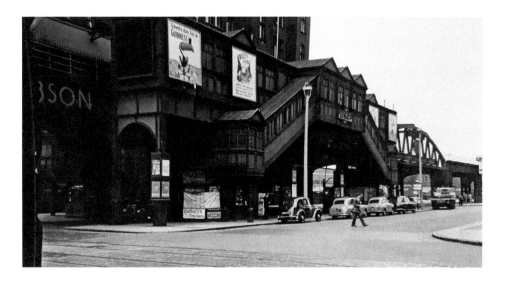

Overhead Railway

Launched in 1893, this novel transport system towered over the streets of Liverpool for over sixty years and was the first such electric elevated network in the world. With approximately 7 miles of rail track, the Docker's Umbrella, as it was locally known, provided commuters with a revolutionary form of transport with unparalleled views from Dingle in the south to Seaforth in the north. Its tracks stood approximately 5 metres above the roadway and took 25,000 tons of iron and steel to construct.

By the 1950s the Overhead Railway was showing serious signs of decay with engineers highlighting structural concerns regarding its iron viaducts. Corrosion and general wear and tear had taken its toll on the old network, and passenger numbers had fallen considerably since the introduction of trains and trams. Efforts were made to secure funding to save the aging track but with a repair bill of over £2 million, the overhead railway was closed in 1956. Little evidence remains of this once iconic transport system, but a small number of iron support columns can be seen built into dock walls along its former route.

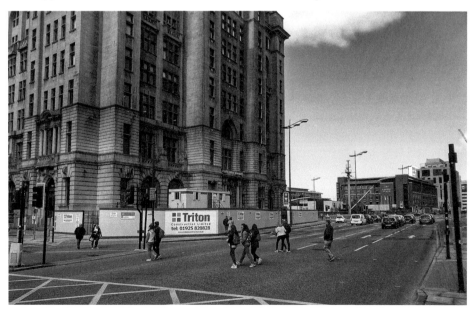

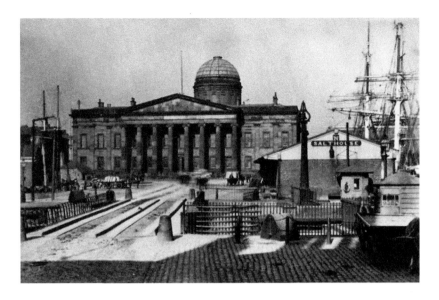

The Custom House

This palatial waterside structure was designed in a neoclassical style and once housed a post office, the dock office and associated offices for Customs and Excise. It was built in 1839 on the site of the city's Old Dock and with its amazing dome and substantial classical columns, the building was one of Liverpool's most recognisable landmarks until its twentieth-century demise.

The Custom House fell victim to enemy endeavours during the Second World War and was set alight during the May Blitz of 1941. The carnage saw the collapse of its precious domed roof and its internal floors razed to the ground. The disaster left the building as little more than a charred shell, but its heavy sandstone walls remained intact. With the war over it was decided that, considering the wider need to rebuild the city, the old Custom House was too great a burden to restore. The area was cleared and the Liverpool ONE development now stands on the site.

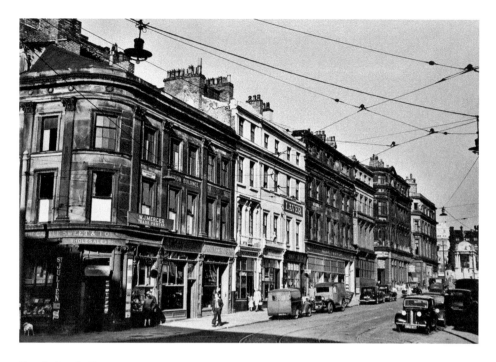

South Castle Street

South Castle Street was once a busy thoroughfare that had numerous retailers and tradesman based there. The street linked the Custom House and the Town Hall and took its name from the thirteenth-century fortress that once guarded this important maritime community. South Castle Street was heavily bombed during the Second World War and many of its historic buildings were destroyed.

Princess Anne formally opened the Liverpool ONE development in 2008 and celebrated the completion of the second phase of this £1 billion retail development. Its construction saw South Castle Street wiped from the maps and the land on which it once stood is now occupied by the modern shopping development, urban parkland and the nearby Queen Elizabeth II Law Courts.

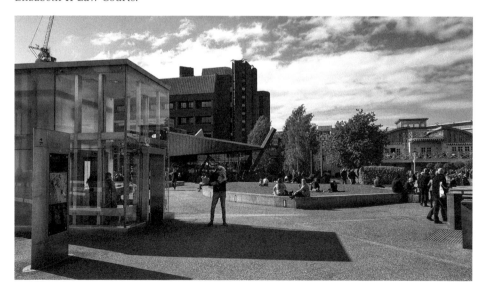

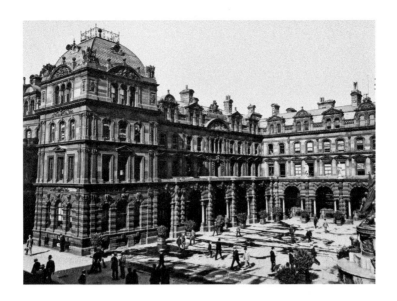

Exchange Flags

Merchants have carried on their business dealings on Exchange Flags for centuries. The first Exchange was constructed here by John Foster Snr in 1808 in a restrained neoclassical style, while the version seen in this image was completed in 1867 and influenced by the impressive architecture of the French Renaissance. Positioned at the rear of the Town Hall, the flags were often the scene for protests and public meetings centred around the Nelson monument, unveiled in 1813.

Today few business dealings are conducted on the flags, but the city's business district has grown up around this historical place of trade. The Victorian exchange was replaced in the 1930s with a design by Gunton and Gunton and provides commercial office space to a host of local businesses. Parts of this building were adapted with the creation of a bombproof bunker from where Britain's campaign against the threat of German U-boats was orchestrated. The Western Approaches Command Headquarters is now a popular museum of international importance.

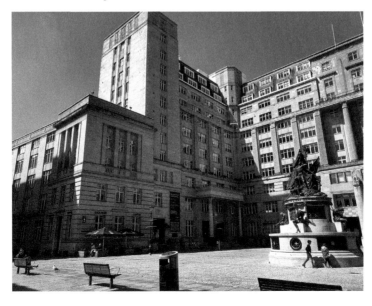

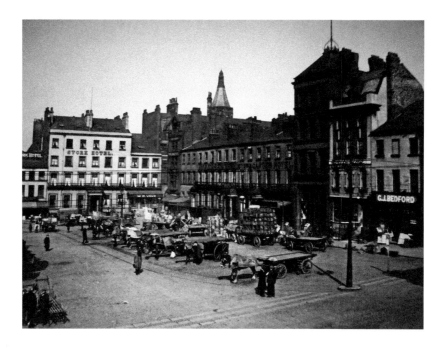

Queen Square

Queen Square was laid out in the eighteenth century and named after Queen Charlotte of Mecklenburg-Strelitz, consort to George III. It had originally been lined with an assortment of commercial enterprises such as inns, hotels and offices, but 200 years later the square was home to an open-air fruit and vegetable market and could often be found besieged with merchants and their produce.

In the 1970s much of Queen Square succumbed to the bulldozer and the area faced a substantial redesign. The mix of Georgian and Victorian buildings were demolished and today the area is home to a mix of restaurants, a car park and a hotel dating from the 1990s. The square itself has also been heavily altered, with part of the historic plot now occupied by bus stops of nearby Roe Street.

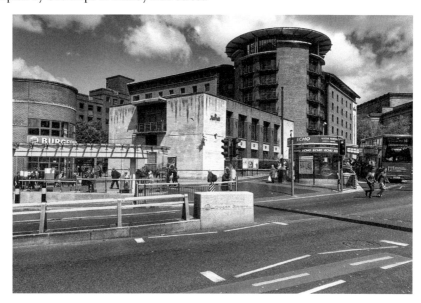

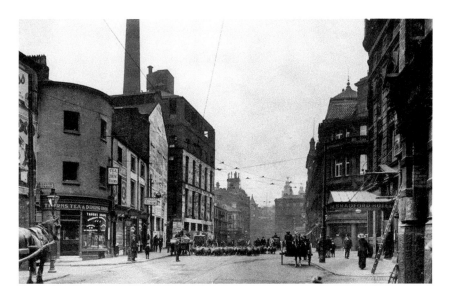

Tithebarn Street

A simple timber tithe barn was erected on this street in the early sixteenth century as a place where locals would pay tax. The building gave its name to the street and through the years the neighbourhood grew with the construction of warehouses and commercial enterprises. The proximity of the railway station also encouraged the establishment of hotels and public houses, with inns such as the Lion Tavern, the Stag Vaults and the United Powers opening to take advantage of the constant flow of potential customers.

The key building here is now the Liverpool Civil and Family Court. This five-storey glazed structure was completed in 2006 and occupies a substantial plot on Tithebarn Street, Vernon Street and Moorfields. The street also features a mix of residential apartments and offices, which are housed in buildings from across the eras. Many of the old pubs have given way to new development, but the historic Lion Tavern remains in business.

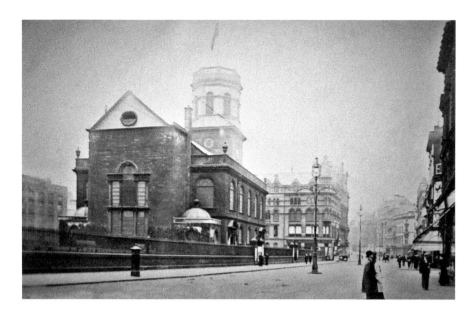

St Peter's Church

The church was consecrated in 1704 and gave the name to the street on which it stood for over 200 years. Completed at a cost of £4,000, the building is believed to have been designed by master builder John Moffat, whose descendants practised as local masons throughout the Georgian era. Its tall octagonal tower was a feature known to Liverpudlians and contained eight enormous and melodic bells.

The church continued to offer services until the twentieth century, an era that saw the construction of the amazing Anglican cathedral on St James Mount. Its commission signalled the end for St Peter's, as the church sold off its valuable city centre asset to help raise funds for the epic project. The church conducted its final service in 1919 and was demolished three years later. Today only a small Maltese cross embedded into the Church Street pavement offers any evidence as to the former spiritual nature of this address.

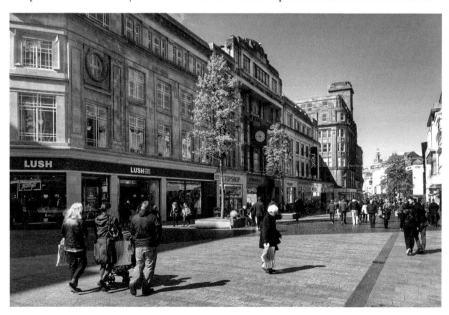

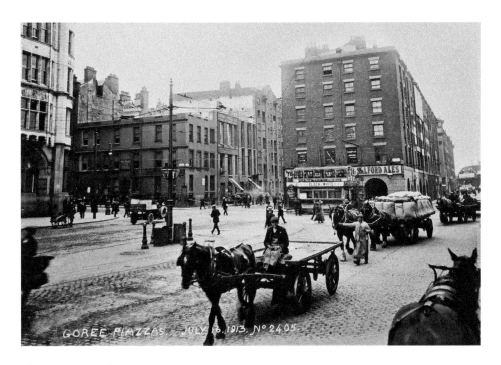

The Goree Warehouses

An assembly of huge multistore warehouses was built here in 1793 for storing goods and merchandise from across the globe. These properties were overcome by fire in 1802 but later rebuilt on a smaller scale. The Goree Warehouses were named after Senegal's Goree Islands, found off the coast of Africa, an important depot for the international trading of slaves.

Traffic travels through the site of the old warehouses, which were razed to the ground in 1958. They had suffered extensive damage during the war and were deemed uneconomic to retain. This area is now dominated by busy carriageways. The Strand is one of Liverpool most important routes, and is overlooked by many of Liverpool's most recognisable and iconic buildings.

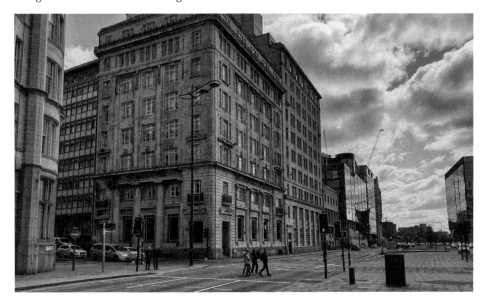

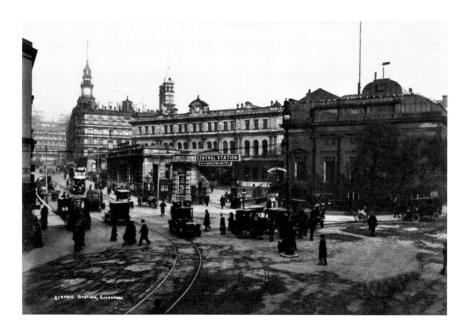

Central Station

Central station first opened in 1874 after the demolition of numerous commercial properties that formerly stood on this site. The station was originally a large three-storey sandstone building with a trio of platforms above ground level. Passengers accessed its principal entrance from Ranelagh Street at its corner with Bold Street, flanked by an imposing pair of ornamental iron gates.

The station became an integral part of the new Merseyrail network in 1970, linking passengers with the Wirral line under the River Mersey via James Street, and north through Lime Street and Moorfields. It was also redesigned to offer rail users a more modern experience, with a new booking hall and a small shopping complex. The station's concourse and facilities were refurbished in 2012 and plans are now in motion to once again improve the building's appearance.

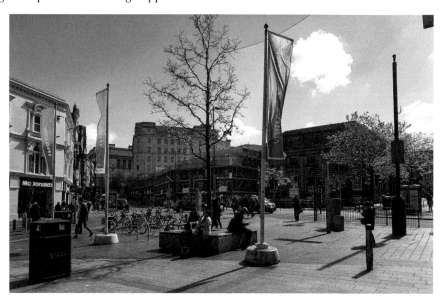

The Cotton Exchange

The Prince of Wales formally opened the Cotton Exchange in 1906. It boasted a strong neoclassical façade beneath a pair of extravagant baroque towers. Inside was an impressive trading hall complete with a Cotton Brokers ring around which deals were conducted. This was the first purpose-built cotton exchange in the world and even had a direct transatlantic cable to New York. At its peak in 1911, over 5 million bales of cotton were traded in a single year.

The façade of this building was replaced in the 1960s to designs drawn up by architects Newton-Dawson, Forbes and Tate, but its side elevations have remained largely unaltered. Stone figures that once formed part of the orginal Edwardian building upon its matching towers can now be seen and appreciated at ground level. The building itself is now occupied as commercial office space and its former trading hall is now an open courtyard.

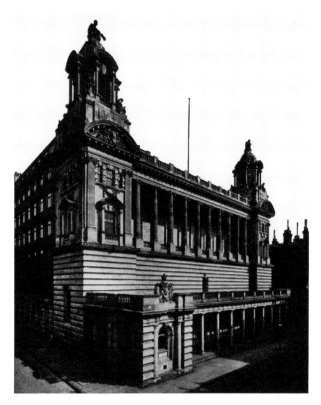

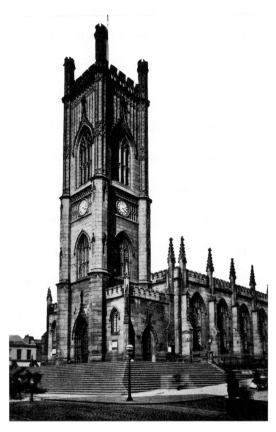

St Luke's Church

Designed by John Foster Snr, the foundation stone for this well-known church was laid in 1811, but it took another twenty years for works to be completed by his son, and services finally commenced in 1832. It was completed in a Perpendicular Gothic style in ashlar sandstone, complete with handsome boundary treatments with decorative gate piers, stone steps and iron railings. The church served as a convenient place of worship in the heart of the city for over a century.

An incendiary bomb set this building alight on the night of 6 May 1941 and by the morning the church was little more than a smouldering sandstone shell. Its timber pews were transformed into charred mounds of debris and its beautiful stained-glass windows shattered beyond repair. St Luke's was never restored but its grounds were sensitively landscaped as public gardens. The ruin has since been repurposed as a unique event space and stands as a lasting memorial to those victims lost in the war.

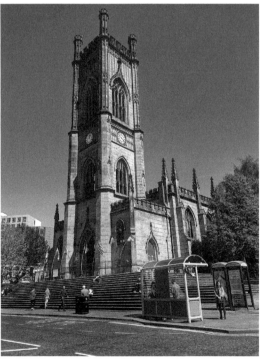

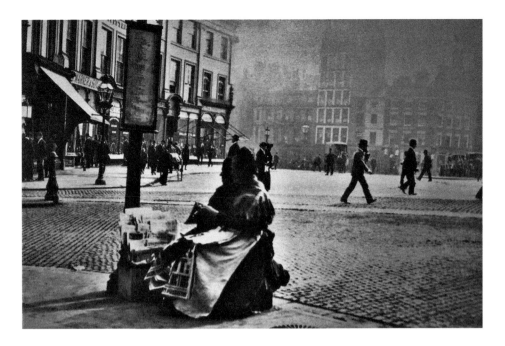

St George's Crescent

A crest of properties first appeared here in the early nineteenth century when efforts were made to widen the old and unsuitable roads emanating from the site of the former castle. Building work was completed in 1827 and the results were widely acclaimed as fitting additions to the aesthetic appeal of this growing town.

This area was heavily bombed during the Second World War and St George's Crescent did not escape the carnage. It was, however, rebuilt in a design similar to the original after the war and follows the same curve as its historic predecessor. It now provides office space within its upper levels and a small variety of commercial units below.

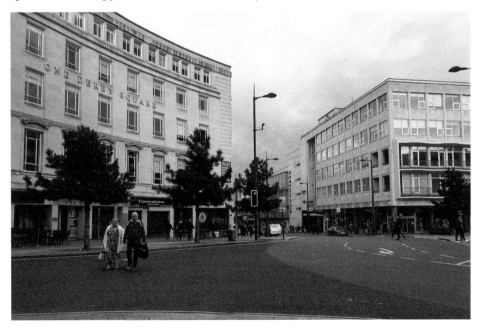

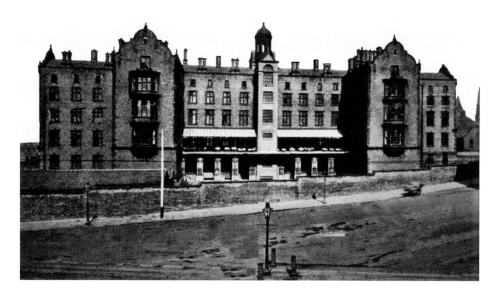

The Workhouse

One of the most dreaded destinations of Victorian life, the Liverpool Workhouse stood at the top of Mount Pleasant and Brownlow Hill. The earliest parts of the building began in 1772, with new additions and extensions taking shape throughout the eighteenth century. A major redesign was carried out in the 1840s and it became one of the largest such institutions in the country.

Workhouses no longer feature in our towns and cities thanks to the introduction of revolutionary welfare laws in the early twentieth century. The Liverpool Workhouse closed in 1928 and the site was soon cleared to make way for the Metropolitan Cathedral. This was initially built to the designs of celebrated architect Sir Edward Lutyens, but what was to be world's second largest cathedral failed to materialise. Financial implications during the war saw the cathedral redesigned by Sir Frederick Gibberd in a far more modest style and completed in 1967.

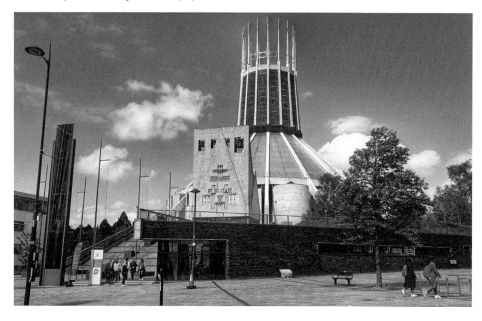

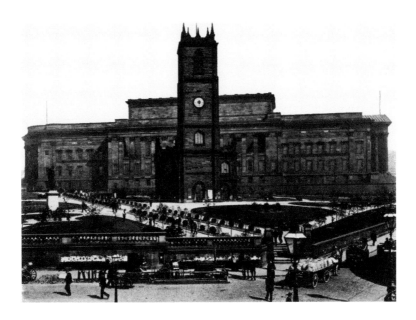

St John's Church

St John's Church once stood at the rear of St George's Hall, with its first services taking place in 1784. This Gothic Revival structure served some of the poorest of the population and its grounds provided a final resting place to over 80,000 bodies. The church was demolished in 1898, allowing the neighbouring hall to be fully appreciated from all vantage points.

The space behind the hall was remodelled as St John's Ornamental and Memorial Gardens in 1904 to the plans of city surveyor Thomas Shelmerdine. As well as extensive gardens, it contains several statues including the impressive bronze monuments to the King's Liverpool Regiment, Prime Minister William Gladstone and philanthropist William Rathbone. The gardens continue to provide a welcome green space in the heart of the city.

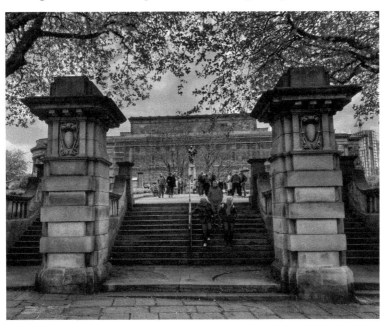

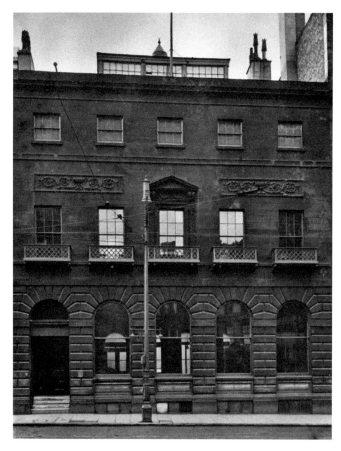

The Athenaeum

The Athenaeum was established in 1797 as a private members' club dedicated to knowledge and learning. The orginal building could be found in Church Street and was set up after local merchants complained of the lack of consistent news reports. The Athenaeum provided its members a space to share and discuss the latest goings-on in a congenial setting and helped to inform their business dealings both home and away.

The 1920s saw a transport revolution and the arrival of electric trams demanded that Church Street be widened, and any obstructive buildings cleared from the townscape. The Athenaeum was one such property but after negotiation, members were able to secure ownership of a new building in nearby Church Alley. A series of shops now stand close to the orginal site of the Athenaeum, with construction dating from the 1960s.

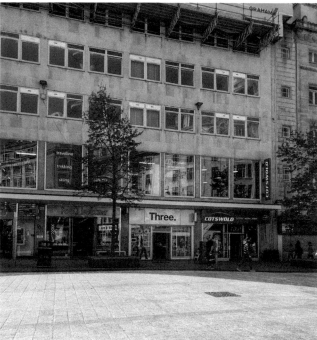

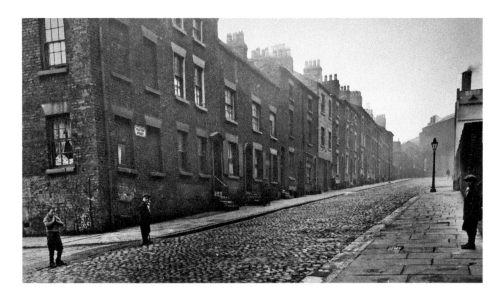

Clayton Street

This street had been a rather downmarket place of abode sandwiched between unsophisticated court dwellings and a mix of industrial premises. By 1870 the scene had changed with many of the old courts swept away from its southern boundary to enable the construction of a library and museum, as well as space for a nearby vegetable market. By the close of the century construction of the Picton Reading Room and Walker Art Gallery had been completed, significantly improving Liverpool's cultural offer. Clayton Street survived into the 1960s but was eradicated by the arrival of the Churchill Way flyover.

Clayton Street has been eliminated from modern views and the area is now home to little more than a public footpath connected to the flyover bridge. In 2019 it was discovered that after years of heavy traffic the flyover was suffering from structural defects and plans to demolish this divisive piece of municipal infrastructure were put into action. The library underwent a major refurbishment in 2013 and the adjoining reading room, museum and gallery continue to welcome visitors from all over the world.

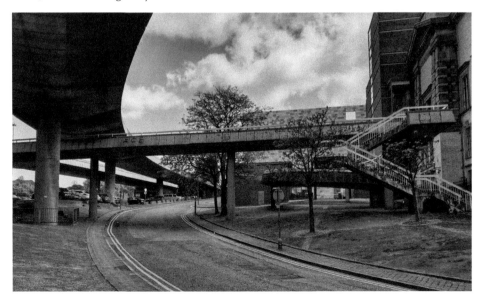

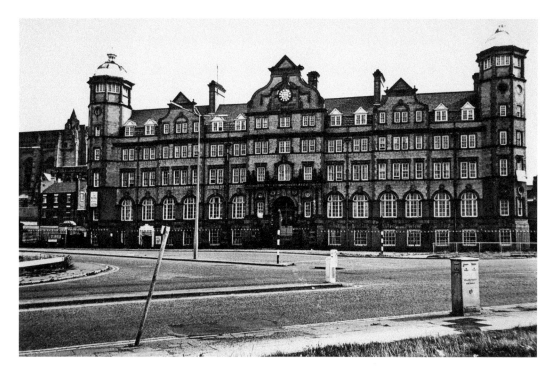

The David Lewis Hostel

Constructed in 1906 on the site of the old St James's Market, the David Lewis Hostel stood in Great George Place and housed a theatre, a club and a hostel with sports facilities, such as boxing and billiards. The project was funded from the estate of businessman David Lewis, who was a generous philanthropist to the poor of both Liverpool and Manchester.

The building was one of the city's most recognisable landmarks and enjoyed popularity throughout much of the twentieth century. It was nicknamed locally as the Davey Lou but by the 1970s the venue had fallen out of favour and the site was targeted for a road widening scheme. The building was finally demolished in 1980. Residential properties now partially occupy the old hostel's footprint, as does the traffic that flows along Great George Street.

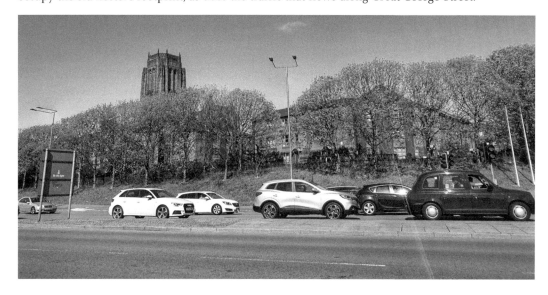

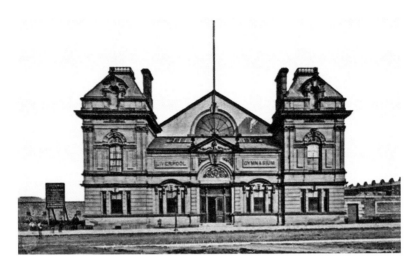

The Liverpool Gymnasium

The mid-nineteenth century saw Liverpool become a focal point for gymnastics and athletics. Local pioneers John Hulley and Charles Melly set up the Liverpool Olympic Festival, an event now widely recognised as contributing to the rebirth of the modern Olympic Games. In 1865 the pair contributed further to the popularity of physical activity and established the Liverpool Gymnasium in Myrtle Street, described as one of the finest of the day. At £14,000, it was believed to be one of the most expensive such establishments of its time and was popular with young men seeking to improve their physical prowess.

In 1880 the building was presented to the Young Men's Christian Association. During the war the building was requisitioned by the British Army, who allegedly failed to maintain the property as necessary. On its return to the YMCA, the size and scale of repair works proved too costly to implement, and the property was sold to the National Health Service as office space. Over time the building became surplus to requirements and was demolished in the 1970s. Nothing remains of the historic gym and the site is now home to a bar situated within Liverpool's university district.

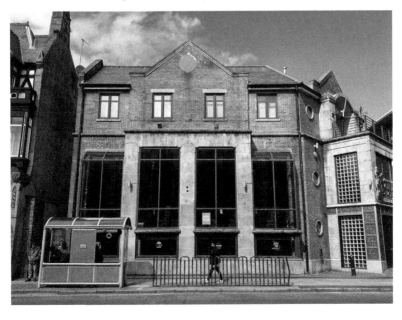

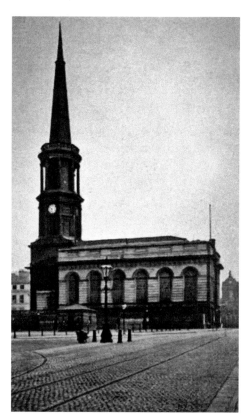

St George's Church

Built on the site of Liverpool Castle, St George's Church was consecrated in 1734. It was designed by Thomas Steers, who had designed the world's first commercial wet dock in Liverpool earlier that century. The church had originally been constructed on the site of the castle moat. Inside stood a number of pews surrounded by an elegant and decorative interior, with its galleries supported by classical Corinthian columns. St George's was the church of choice for local officials including the mayor, aldermen and judges, who often to be found in attendance.

The scene today is dominated by the Queen Victoria Monument, which was formally unveiled by her daughter Princess Louise in 1906. Cast in bronze, the monument was designed by F. M. Simpson of the Liverpool School of Architecture, assisted by the local architectural firm of Willink and Thicknesse and decorated with additional sculptures by C. J. Allen. It replaced the old church, which was torn down in 1899 after an unsustainable fall in the number of parishioners, and now stands as a recognisable landmark to many.

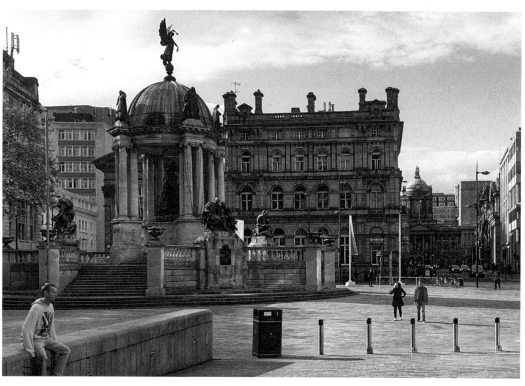

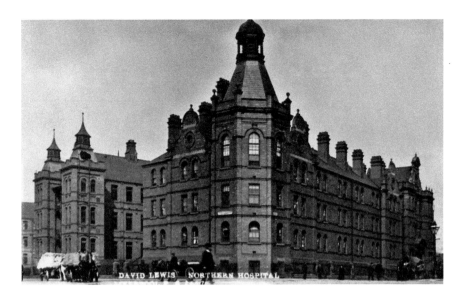

The Northern Hospital

In 1902 the David Lewis Northern Hospital was formally opened in Great Howard Street. It aimed to help the expanding population of northern Liverpool and handle the increasing number of dockside accidents and emergencies. The building was granted financial assistance from its eponymous benefactor and replaced an earlier hospital that had stood on the same site since 1845. Various additions were added over the years, but the Northern Hospital finally closed in 1978 when services were relocated to the new Royal Liverpool Hospital.

The twenty-first-century century view shows the site cleared of all remnants of the former hospital and instead an assembly of car showrooms now stand at this busy junction with Leeds Street. This is a main arterial road for the city and is destined to see an increase in future development, with apartments and hotels and quite possibly Everton FC's brand-new football stadium all set to rise up in and around this pre-eminent riverside location in the coming years.

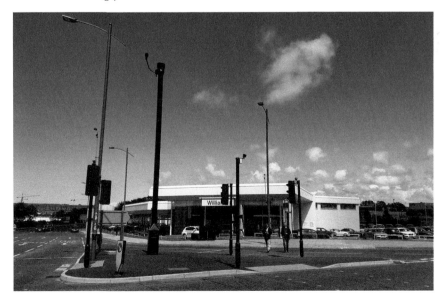

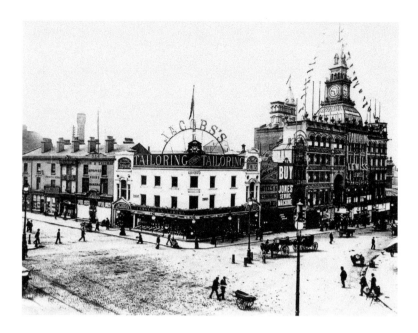

Lewis's Building

The household name that is Lewis's has its roots back in 1856 when businessman David Lewis founded his first fledgling clothing store. The venture proved to be a phenomenal success with stores spreading across the north-west. Sadly its flagship Liverpool store was eradicated during the Blitz of 1941. It would take another decade before a new building would take its place.

The replacement store was designed by the firm of Gerald de Courcy Fraser with the main building consisting of seven-storeys within a steel frame and Portland stone façades. The architect incorporated the adjacent Watson Building on Renshaw Street into the new design, which had somehow miraculously survived the war. Artist Sir Jacob Epstein was commissioned to create a trio of decorative panels and a unique and prominent sculpture, *Liverpool Resurgent*, which now looks out across the city.

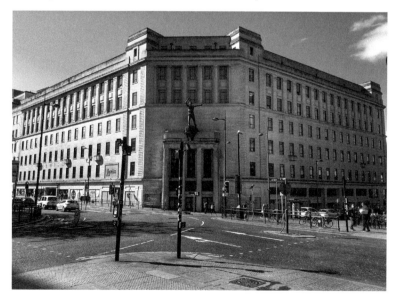

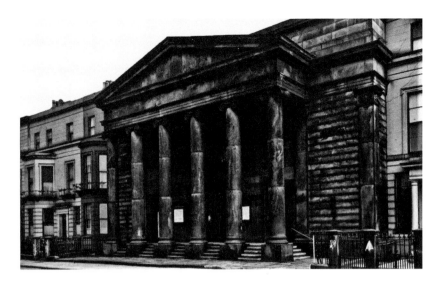

St Catherine's Church

Once positioned among Abercromby Square's arrangement of elegant town houses, St Catherine's Church was built to the design of John Foster Snr in 1831. It boasted a handsome classical portico, but its central glass dome was small and inefficient. The church served some of the wealthiest of Liverpool society as it was ideally located within one of the town's most sought-after residential squares.

Liverpool University acquired many of the historic properties in Abercromby Square in the 1960s. By this time St Catherine's had become yet another victim of the Blitz and stood as a burnt-out shell. The church was demolished to make way for the Sydney Jones Library, which was designed by Sir Basil Spence in 1976 and named after the four-time Lord Mayor of Liverpool, Sir Charles Sydney Jones. Spread over four floors, it is one of two main libraries belonging to the university and houses thousands of books alongside a suite of computers and study rooms.

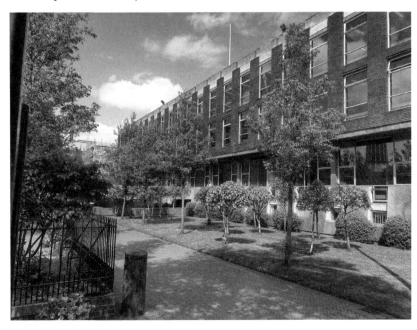

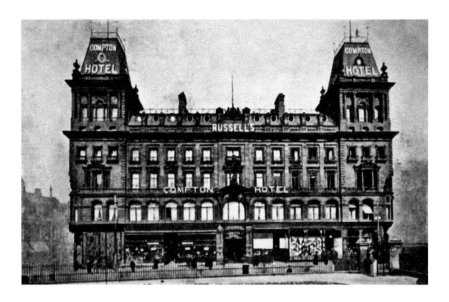

Compton House

From the 1850s Compton House was occupied by Jeffrey & Co., a business headed by American brothers William and James Jeffrey. It was one of the world's earliest purpose-built department stores, pre-dating the famous Bon Marché of Paris by five years. In 1865 the orginal building was destroyed by arson by a disgruntled former employee. In the 1870s the upper floors of Compton House were converted for use as a hotel, which was particularly popular with American tourists.

The new building was designed in a matter of weeks and construction was completed in eighteen months. It boasts a sandstone face sourced from Wirral's Storeton quarry and robust French-inspired pavilion towers, which have been lost over time. Today the building has reverted back to sole use as retail and has been home to Marks and Spencer's since 1927. Architectural details from its time as a hotel remain and can be spotted in the stonework, which includes a rather grand American eagle peering down over Tarleton Street.

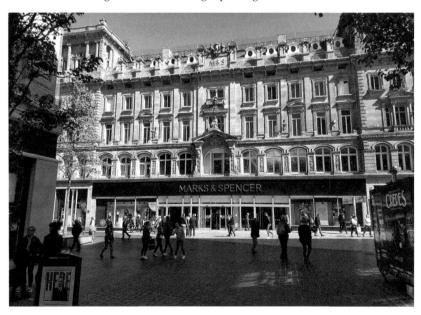

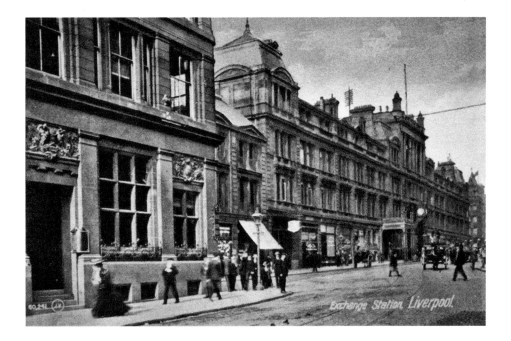

Exchange Station

A new railway station opened in Tithebarn Street in 1850. The Italianate building had originally been elevated high above the street on brick arches to allow locomotives to clear the nearby Leeds to Liverpool canal. In the 1880s the canal was altered to allow the building to be substantially redesigned to accommodate increasing passenger numbers, along with the addition of a hotel. In 1977, after over 150 years of service, the station closed, and trains were transferring to the newly constructed Moorfields station.

Most of Exchange station was demolished in the 1980s but its grand stone façade was retained during subsequent development works. At the rear the old rail tracks have been cleared and the area used as a car park. The property is now known as Mercury Court and serves as office space, but its former name can still be observed beneath the building's roof balustrades, as can its much-loved station clock high above the entrance arches.

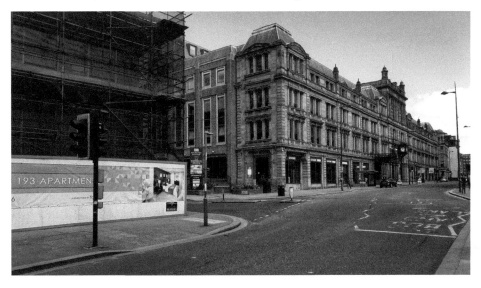

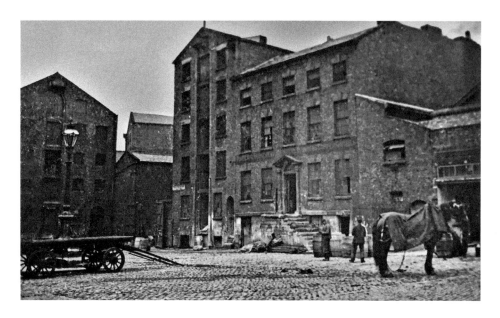

Wolstenholme Square

The square dates from the mid-eighteenth century and is believed to be the first neighbourhood in the city to feature a central garden. Early recollections describe the area as a ladies' walk consisting of an avenue of trees extending upwards as far as Colquitt Street. As the nineteenth century grew closer, the locality became increasingly industrialised with tall warehouses built to serve the progressively busy port.

It is only in recent times that Wolstenholme Square has returned to its residential roots with the development of a host of new apartments. This revolution has completely transformed the appearance of the area with some of the tallest residences taking shape here. Its development has, however, brought an end to the neighbourhood's hedonistic venues with the loss of several nightclubs. The unusual and colourful public sculpture of *Penelope* has survived the bulldozers, having been a focal point here since 2002.

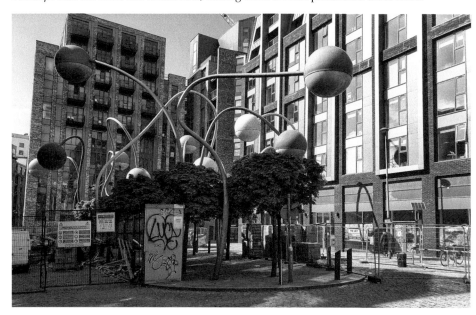

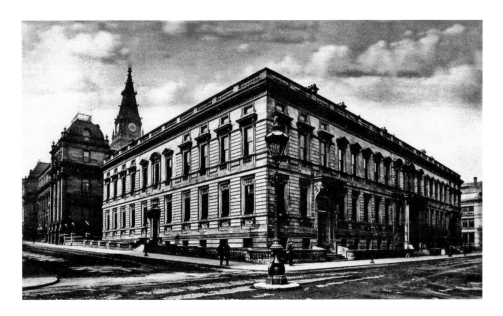

Government Buildings

The once imposing Government Buildings was constructed in the 1870s to plans drawn up by architect John Williams. Designed in a dignified and classical style with Portland stone, it was occupied by the Ministries of Health & Agriculture, the Assistance Board, the Inland Revenue Stamp Office and other associated governmental departments. The site was struck by a high-explosive bomb during the Second World War and stood as a charred ruin for almost a decade.

The site was eventually cleared for use as an inner-city car park, which covered much of the orginal footprint of the building. In 2017 a new multistorey car park was built on the site to provide space for over 300 vehicles in a £6.5 million scheme. Its construction was not without protest, with many lamenting the loss of trees from the locality combined with fears of a substantial increase in city centre traffic.

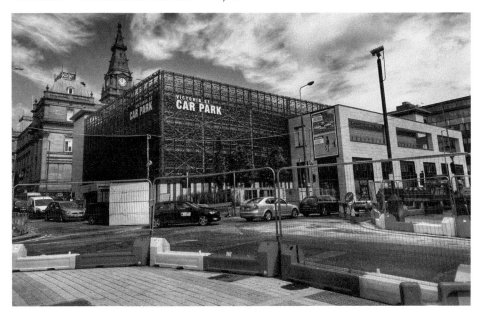

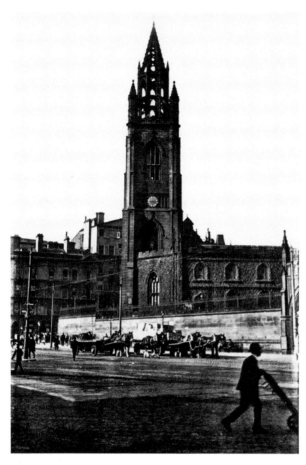

Church of Our Lady and St Nicholas

It is believed that the land on which this church stands has been used as a place of worship since 1257. In the middle of the fourteenth century the Black Plague ravaged the population by half, leaving only an estimated 500 survivors. The human cost forced the church grounds to be consecrated for burials and later a new and improved chapel dedicated to St Nicholas was constructed.

Most of the church seen today dates from the 1950s when the building was largely reconstructed having been destroyed during the war. Only the tower and the administrative block were left unscathed. Prior to its reopening services continued within the ruins with the opening of a makeshift chapel. Architect Edward C. Butler successfully incorporated the surviving features of the old church with the new, which was consecrated on the Feast of St Luke in 1952.

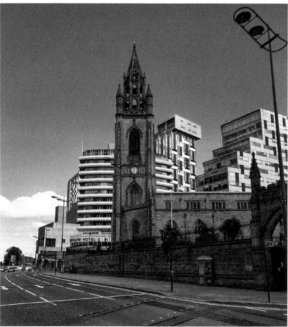

The Lord Street Arcade

This commercial arcade dates from the final days of the Victorian era, having been completed in 1901 to the designs of Walter Aubury Thomas. It was finished in mix of red and orange horizontal stone bands beneath a trio of large segmental arches. Early purveyors to move into the arcade included R. & J. Blacker, the hatter and collar specialists, Herbert Wolf, a jeweller and diamond mounter, B. Dobell & Co. Ltd, coal merchants and Gaze's Tours, offering what was described as, 'Tours & excursions by land & sea to all parts of the world.'

The once spectacular arcade has since been converted into several divided units and no longer features the stunning glazed interior experienced by shoppers in the previous century. Its polychrome exterior remains and today the magnificent property stands as one of Lord Street's most impressive architectural works.

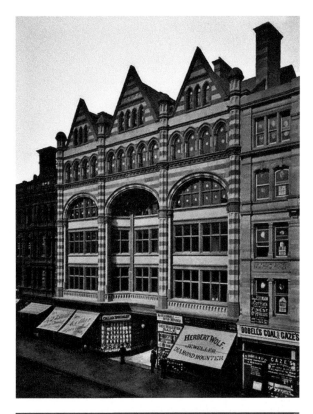

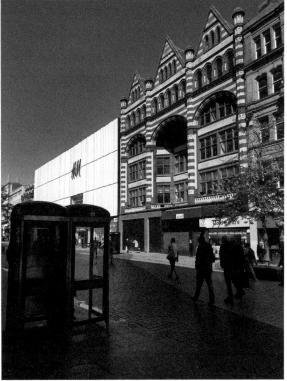

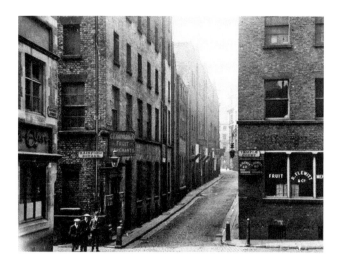

Mathew Street

During Liverpool's early years this part of the town was largely agricultural, but as Liverpool grew in power and importance the land around this lively port became a valuable commodity. This fact was not lost upon Mr Mathew Pluckington, who secured a large plot not too distant to the waterfront. His purchase later became known as Pluckington's Alley and by the mid-eighteenth century was home to a horde of traders and residents. Through the decades the alley developed to even greater proportions, populated by multistorey warehouses packed high with produce imported from all over the world. In time the alley also shook off its vernacular moniker and was renamed in honour of the original landlord, spelling included. Of course, it is chiefly remembered for its connections to the Beatles and the famous Cavern Club, which once stood here.

Many properties here have been converted into bars and nightclubs, and the street is frequently swamped with tourists all eager to walk in the footsteps of the Fab Four. In 1972 British Rail took over the Cavern Club with plans to construct a ventilation shaft for the underground railway. Bulldozers moved in to raze the building at street level and the original cellar was filled in with the rubble. In the end the proposed shaft was never built, and it took a decade for the idea to bring the Cavern back to life to be seriously considered. Structural issues meant that the original cellar itself could never be resurrected, but in 1984, 15,000 bricks from the Cavern Club site were used in the reconstruction of a new version just yards away.

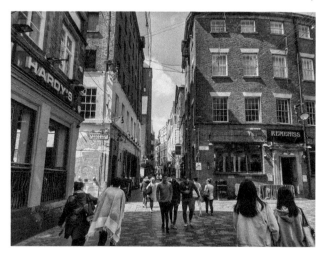

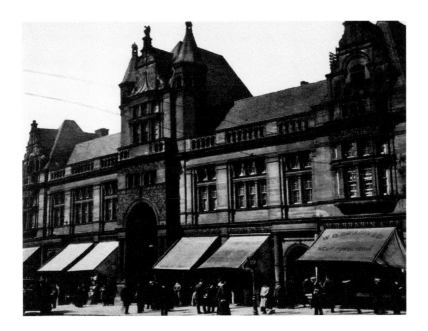

St John's Market

In times gone by St John's Market had the honour of being the first covered general food market in Britain. It was designed in 1822, along with many other city buildings, by John Foster Jnr. He pictured a huge parallelogram nearly 2 acres in size and incorporated numerous classically inspired arched windows beneath a timber roof. The American painter and naturalist John James Audubon described the structure in glowing terms: 'The new market is, in my opinion, an object worth the attention of all traveller strangers, it is thus far the finest building I have ever seen.'

With the war over the city's attention focussed on rebuilding as several surviving older properties like St John's Market fell into a state of disrepair. Combined with a noble vision to regenerate the city centre for a new era, the market was demolished in the 1960s. A new market was built and the road, with its steep incline, was redesigned to feature a series of staggered steps. A market hall was recently unveiled within the complex but has failed to generate the custom once enjoyed in earlier times.

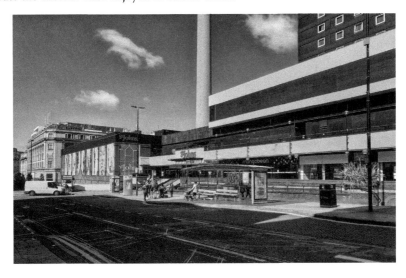

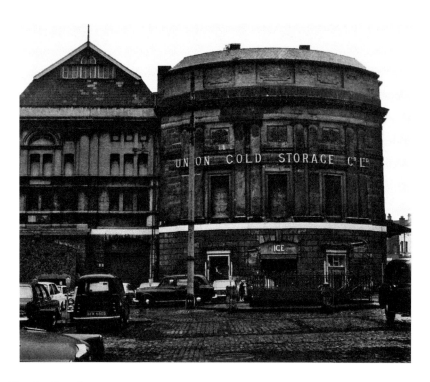

The Theatre Royal

Williamson Square was originally laid out in the mid-eighteenth century for residential use. In 1772 the Theatre Royal was established on its west side, paid for by subscription from a number of wealthy patrons. In 1802 the façade was redesigned with a circular frontage and operated until 1890 when it was adapted to a cold storage unit, before finally being demolished in 1970.

The scene has changed dramatically with the construction of a substantial retail block currently housing branches of the clothing stores Matalan and New Look, as well as the official Liverpool FC store. The curve of the lost Regency building has inspired the development of the neighbouring Playhouse Theatre's 1960s tubular extension. One of most striking changes to this scene has been the installation of a large ductile iron fountain installed within the pavement in 2004.

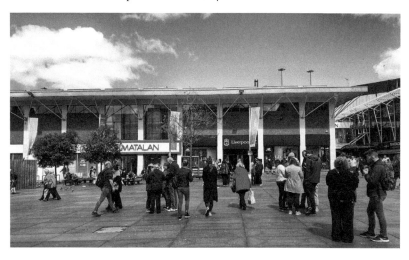

Commutation Row

Constructed in the late eighteenth century, Commutation Row derived its name from the Commutation Act of 1784. This was a political move by the government of William Pitt the Younger to tackle the thriving world of smuggling, especially in tea. The Act reduced the tax on the commodity to render it an unprofitable criminal enterprise and commuted the reduction in duty directly onto the consumer through the window tax. Buildings here consisted of shops and public houses, typically of three storeys but with individual and eclectic frontages providing a sense of variety and interest to the streetscape.

The late twentieth century saw the loss of this part of the city centre with the demolition of the row. It is now occupied by a large mixed-use office and housing complex overlooking the city's much-admired William Brown Street and the monumental St George's Hall. The design of the building, completed in 2002 by Geoffrey Reid Associates, has attempted to take inspiration from its historic surroundings, but it fails to emulate the impressive character and worthy appearance of its neighbours.

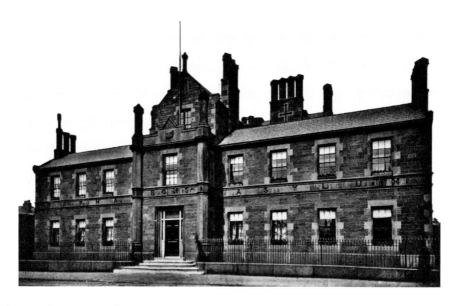

The Myrtle Street Orphanage

A female orphanage was established in Mrytle Street in 1844 in an effort to save young girls who had lost their parents from a life of ruin, misery and crime. Earlier buildings had quickly proven far too small for the sheer number of youngsters finding themselves at the institution. Ten years later a male orphanage was established nearby with the same charitable and benevolent ambitions.

The orphanages lasted until the 1930s when funds were raised to relocate out to new premises in the suburbs of Childwall. The buildings were demolished and Myrtle Gardens, a modern housing development, was constructed on the site. What is left of this municipal housing block stands as evidence of the style of its day, with smooth contemporary curves and sleek art deco features. The interwar housing block was partially redesigned in the 1980s when the building was taken on for private housing and rechristened Minster Court.

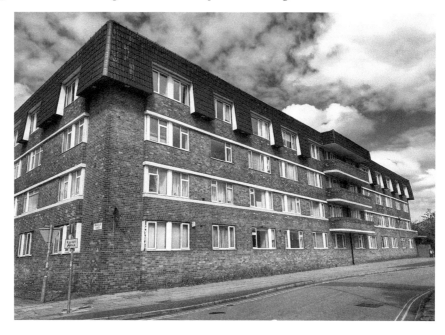

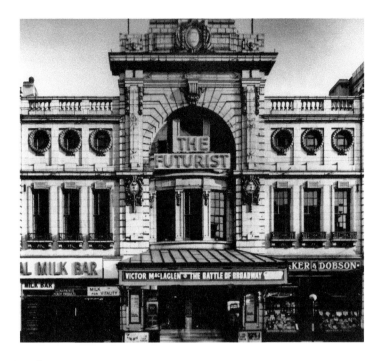

The Futurist Cinema

The Futurist had originally been the Lime Street Picture House when it first opened in 1912 and was one of Liverpool's earliest purpose-built cinemas. Designed with a sophisticatedly ornate neo-baroque façade, it offered a place for locals to experience moving pictures for the first time. The cinema could seat approximately 1,000 patrons, who entered via an impressive entrance foyer adorned with a tiled floor and decorated with Sicilian marble.

The Futurist became the focus of a major legal battle when plans to redevelop Lime Street caused public uproar in 2015. By this time the former cinema had been closed for over thirty years and had fallen into a state of wanton disrepair. The Futurist, along with the majority of its neighbours, were finally demolished the following year and replaced with a monstrous mixed-use block.

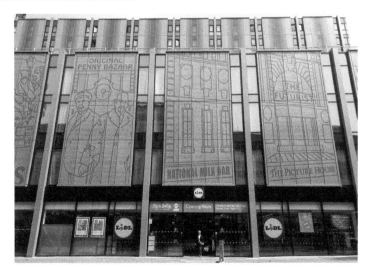

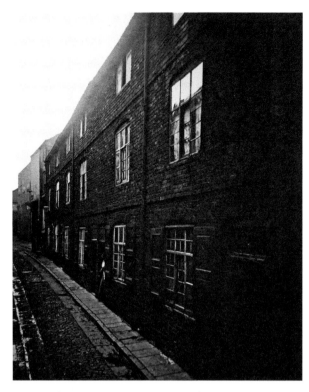

Hockenhall Alley

This small and unassuming thoroughfare was formerly known as Molyneaux Weint and was built just off Dale Street in the mid-eighteenth century. The alley appears to have been named after an ancient Hockenhull family of Cheshire, but exact details of this connection have been lost over time. The passage was lined with very modest terraces housing some of the poorest in Liverpool society, but most of these early Georgian properties were demolished through Victorian regeneration.

Parts of Hockenhall Alley retain a dark and narrow character, but over time many of the buildings here have been brought down and replaced with twentieth-century additions. This includes a large branch of the hotel chain Premier Inn, whose entrance can be found in nearby Cheapside. At No. 10, however, is an amazing surviving example of a modest working-class residence dating from the end of the eighteenth century. This humble structure is a rare reminder of Liverpool life in the distant past, hidden among a busy cityscape of change.

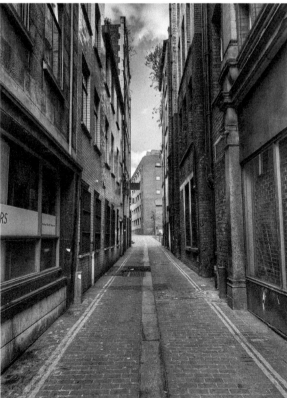

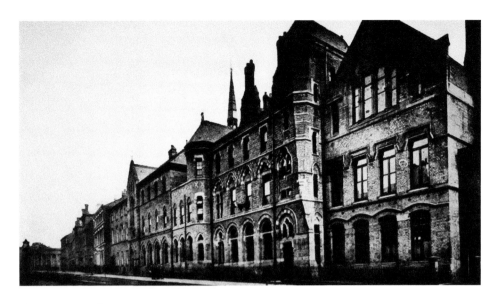

The Convent of Notre Dame

It was in 1856 when five members of the Convent of Notre Dame travelled from the town of Namur, Belgium, and settled among the Liverpool people. Their purpose was to educate the girls of England on the teachings of the Bible and to nurture the religious upbringing of the poor and needy. They established a convent at No. 96 Mount Pleasant and later opened a large training school, designed by Charles Hansom, and a chapel by M. E. Hadfield & Son.

The nuns no longer have a presence here and instead the building functions as part of Liverpool John Moores University. It is now known as the John Foster Building, named after the city's famous architect who lived nearby, and currently teaches students of the School of Humanities and Social Science. The former chapel at the rear of the property has survived and serves as a beautiful and unique learning space.

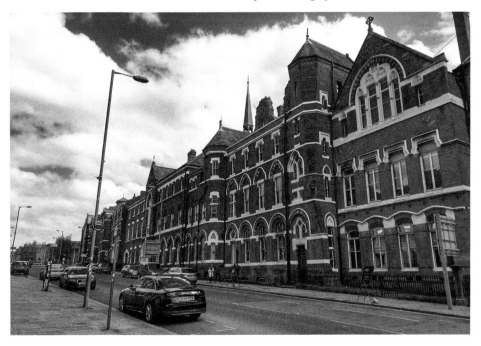

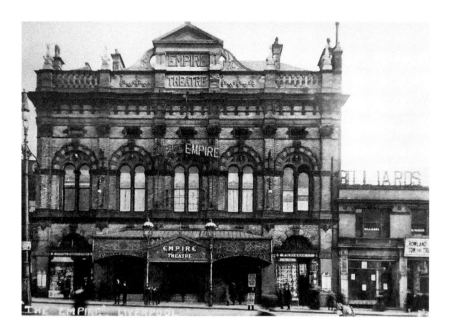

The Empire Theatre

The Prince of Wales Theatre and Opera House opened its doors for the first time in the winter of 1866 with a performance of the opera *Faust*. Back then this was the city's largest theatre, designed in a classical style and handsomely fitted and decorated with a host of fine and intricate features. Stage machinery was powered by means of steam and beautiful gaslights were used to provide illumination. Within a year the theatre was renamed in honour the Princess of Wales and became known as the Royal Alexandra Theatre and Opera House.

The new names and redesigns continued until 1925 when the theatre we know today completed. Today's Empire Theatre was significantly altered by the Milburn Brothers, and was built with a steel frame and faced with Portland stone. Its main frontage is adorned with a set of huge ionic columns with a grand interior inspired by the stylings of Louis XVI. It was a far superior venue compared to its predecessors and noted for its intelligently designed audience sightlines.

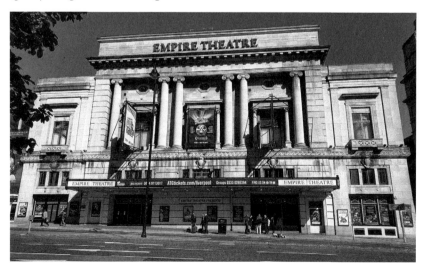

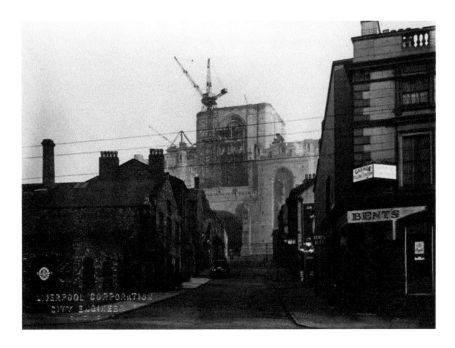

Washington Street

Washington Street was just one of several streets that once stood in the shadow of the enormous Anglican cathedral. It originally housed a row of residential terraces built in the early nineteenth century, located adjacent to an old stone quarry. Much of the raw material from that site was used in the construction of many properties across the city, but the neighbourhood itself no longer survives.

Housing continues to be the dominant use of the site, but Washington Street is no more. Many of the properties that once stood here were damaged during the war, and those that survived were finally swept away in the 1970s in a widespread slum clearance programme. Their removal heralded the arrival of what is now Cathedral Campus, consisting of a range of student apartments set about spherical layouts, with private residences situated nearby.

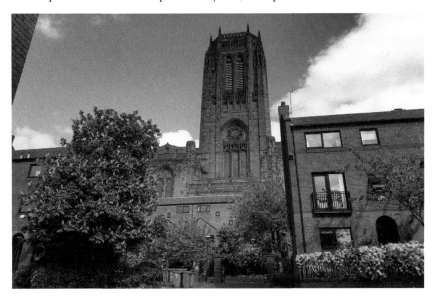

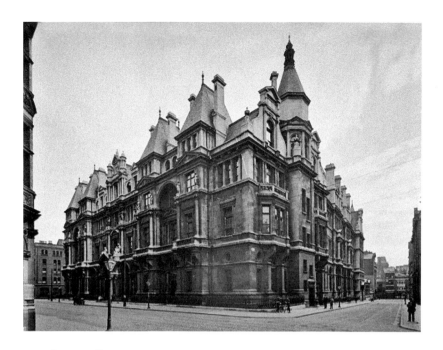

The General Post Office

The General Post Office once stood elegantly between Stanley Street and Sir Thomas Street. It was built in the 1890s by Sir Henry Tanner in an ambitious yet luxurious Italian Renaissance style, second only to the post office of St Martin's-le-Grand in London. The air raid of 3 May 1941 was arguably the worst of the war, with approximately 500 German bombers participating in a seven-hour bombardment over the skies of the city. The raids destroyed much of the post office interior, and officials were later forced to remove the remaining three upper floors which had been rendered dangerously unsafe by enemy action.

The building has since been repurposed as a mixed-use development known as the Metquarter. Opening in 2006, the complex contains numerous high-end brand retailers and boutiques, which can be accessed from Victoria Street, Whitechapel and Stanley Street. It is also home to the Everyman Cinema, which screened its first films in 2018. This cosy picture house contains just four screens and is furnished with bespoke comfort seating. Liverpool's city centre postal services can now be found in Liverpool ONE.

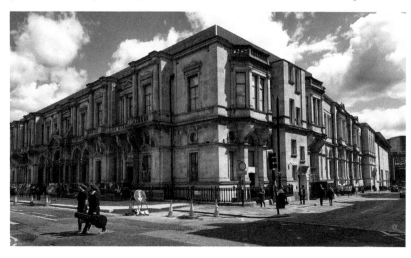

Tower Building

Liverpool Tower is believed to have been built in 1404 by Sir John Stanley as a family home. Two years later a licence to fortify the property was granted and over the years it grew into a small stronghold. Eventually it became the city prison and featured several underground dungeons along with fine civic rooms positioned above. Warehouses were allocated to the site in the early nineteenth century but were torn down in 1856 with the construction of the first Tower Building. The new property was designed by Sir James Picton in an Italianate style and it survived for half a century until work on a new and improved version was commenced.

The most recent incarnation of Tower Building was completed in 1906 and is finished with grey granite and white faience cladding. It stands as one of the earliest steel-framed buildings in Britain and has been a prime city centre address for over a century. In 2006 and again a decade a later, the upper levels of the building were converted for residents, who now occupy seventy-six high-spec apartments in one of Liverpool's most attractive historic buildings.

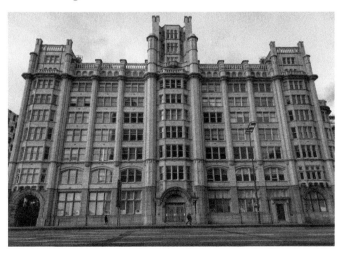

45

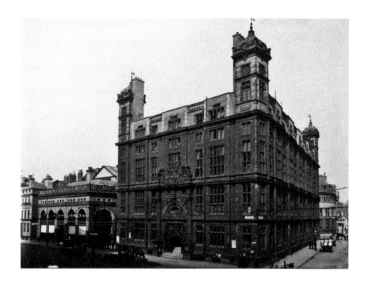

The Sailors Home

The Sailors Home stood on the present-day site of John Lewis after first opening in 1852. The need for such a home had been identified the decade before when it was hoped the city could offer help to seamen frequenting the port with board, lodging and medical attendance at a moderate charge. Staff encouraged the saving of hard-earned wages and promoted moral, intellectual and professional improvement, as well as affording the opportunity for guests to receive religious instruction. The institution was designed by Scottish architect John Cunningham, who had already fashioned Lime Street station and the original Philharmonic Hall.

As time progressed the facilities of the Sailors Home became unfit for purpose and often failed to meet the expectations of modern seafarers. The building closed its doors for the final time in 1969 and was demolished five years later. The land remained undeveloped for decades until the construction of Liverpool ONE. Only the gates of the Sailors Home remain, having been returned near to their orginal location in 2011. They had earlier been relocated to a West Midlands foundry after the war. Some of the building's decorative mermaid panels have also survived, having been incorporated into Sir Clough Williams-Ellis' Welsh wonderland village of Portmeirion.

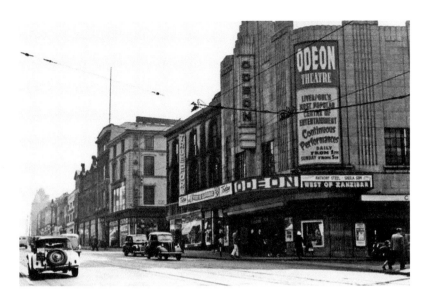

The Odeon

The Odeon on London Road began life as the Paramount in 1934, serving as the largest picture house on Merseyside. It boasted a full stage and a Compton organ, along with 2,670 seats completed in the art deco style. The cinema had been built on the site of an old boxing stadium which had staged bouts at this location since 1911, but this had been forced to make way for the rising popularity of moving pictures after two decades of pugilism. In 1942 Odeon took over the running of the cinema and over time much of the building's decorative features were altered or completely lost as the cinema transformed to suit modern audiences.

London Road's appeal as a destination dwindled significantly over the years, with the commercial hub of the city now centred on Liverpool ONE. The Odeon relocated in 2008 and its latest venue can accommodate over 3,000 cinemagoers. The old branch was demolished a few years later and the site was designated for student accommodation.

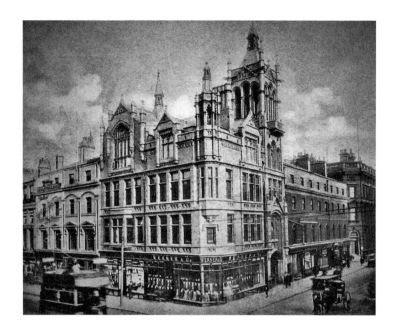

Diocesan Church House

Diocesan Church House was situated in South John Street and housed the offices of the local diocese and its associated records and literature. Its foundation stone was laid in 1899 by the Countess of Derby, who formally declared the commencement of this ambitious and pious project. The building featured a large hall with enough seating for 400 people, a diocesan registry, bishop's quarters, committee rooms and finance offices, as well as a library and reading rooms. The project was championed by Bishop J. C. Ryle, who felt that the institution would be a welcome addition to Liverpool life, promoting widespread unity and understanding.

The events of the war rendered the once beautiful Gothic structure a shadow of its former self, with its lower rooms totally destroyed and its Church Street elevation dangerously compromised. In the twentieth century the whole building was torn down and replaced by an office block, but this too made way for the architecture of Liverpool ONE in 2008, and the colourful lines of the double-height coffeehouse seen today and neighbouring premises.

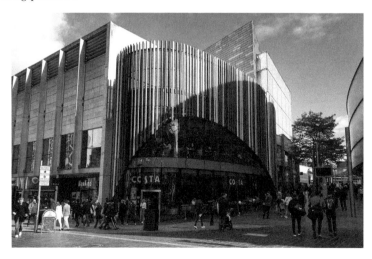

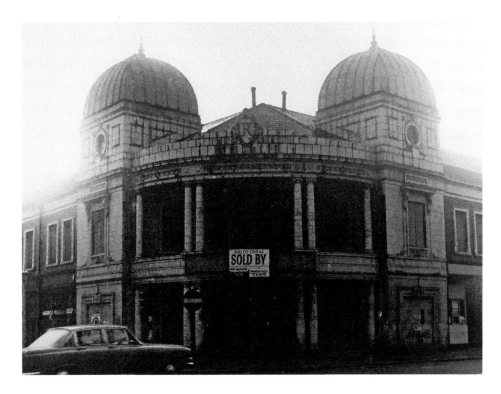

The Rialto

The Rialto had its grand opening on 27 October 1927 at the prominent corner of Upper Parliament Street and Berkeley Street, having been built on the site of a former stables. Those lucky enough to be in attendance that night were the first to discover its luxurious cinema and splendid ballroom, in addition to a garden café and a fully equipped billiard room. The Rialto quickly became one of Liverpool's favourite multi-purpose leisure spots.

By 1981 the Rialto had been transformed into a large antiques and second-hand warehouse, with all manner of furniture piled up into its old cinema and ballroom. The building was disastrously caught up in the infamous Toxteth Riots that summer and was badly burnt during the unrest. The site is now occupied by apartments and shops in a new property somewhat reminiscent of the former lost venue.

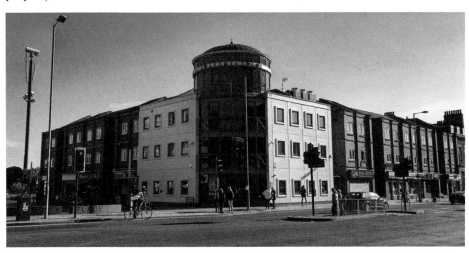

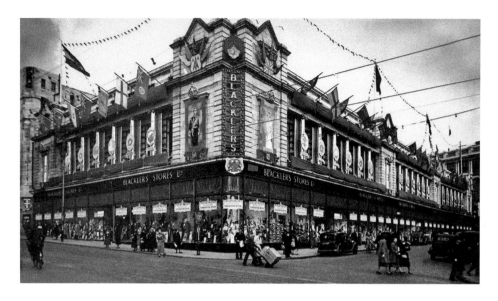

Blacklers Department Store

Blackers was founded by business partners Richard John Blackler and A. B. Wallis, opening in its doors in 1908. The store operated from a large premise at the corner of Great Charlotte Street and Elliot Street, and at its height employed approximately 1,000 members of staff. Blackers is well remembered for its Winter Grotto, which would see thousands descend upon the store to see its giant Father Christmas and the magical scenes within. In 1941 the store was severely damaged in the war, forcing management to open temporary stores in Church Street and Bold Street. Staff returned to their orginal premises in the 1950s until the company's demise in 1988.

The pub chain Wetherspoons now occupies a large part of the former Blacklers store. The building has lost the glazed roof space that originally illuminated the aisles and the space within has been heavily subdivided. The large window displays that once tempted shoppers in have also been lost, replaced instead by seating for pub patrons.

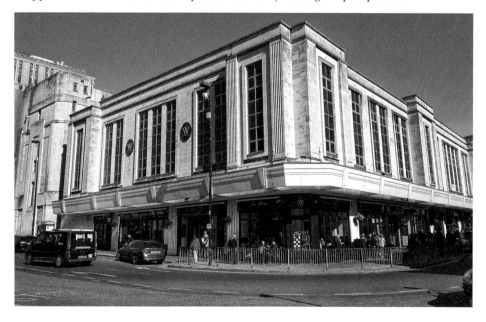

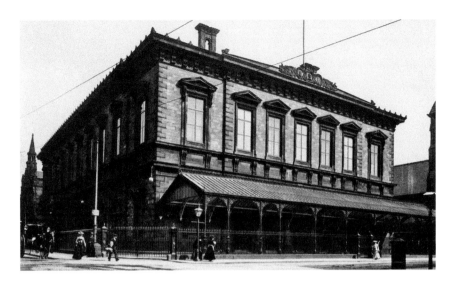

The Philharmonic Hall

The history of the Liverpool Philharmonic Orchestra dates back to 1840 but it was almost another decade before its members had a permanent building to call their own. Architect John Cunningham was commissioned to design a new concert hall to stand at the corner of Hope Street and Mrytle Street. Once completed his building could accommodate over 2,000 patrons, with its first performance taking place on 27 August 1849. One reporter described the hall as 'one of the finest and best adapted to music that I ever entered', and it was widely respected for its particularly excellent acoustic qualities. In the summer of 1933, a blaze broke out on the roof of the building that quickly spread and destroyed the hall.

The building that stands today dates from 1939 and was designed by Herbert Rowse in an art deco style, inspired by the work of Dutch expressionism. It is constructed in fawn brick featuring semicircular stair turrets flanking the main symmetrical entrance. The Philharmonic also features a rear extension added in 1992, and in 2015 the whole building was sensitively refurbished in a multimillion-pound scheme to enhance the architectural heritage and character of the building, while improving the concert experience for musicians, artists and audiences.

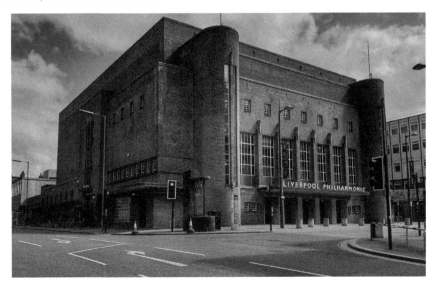

51

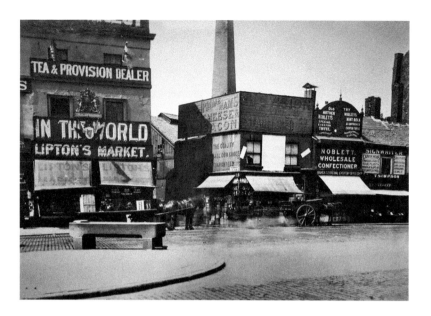

Old Haymarket

As the name suggests, this was once the location of Liverpool's hay market, which operated from at least the early eighteenth century. It had certainly gained historical significance by the Victorian era, during which the area grew to become a busy thoroughfare with both commercial and residential buildings lining the road. The scene changed most dramatically in 1925 when construction of the Queensway Tunnel got underway. The old buildings were torn down and the site cleared beyond all recognition. This was the start of one of the most awe-inspiring engineering projects the world had ever seen, a 2-mile roadway connecting Liverpool and Birkenhead through what would later become the longest underwater tunnel on earth.

Just as city planners envisioned, the tunnel has served as a key transport route and stands as one of the region's most revolutionary engineering projects. It is estimated that approximately 13 million vehicles pass through the tunnel under the Mersey every year. In 1971 the route was joined by the Kingsway Tunnel, located a short drive north of the city centre, connecting Liverpool to Wallasey on the Wirral peninsula.

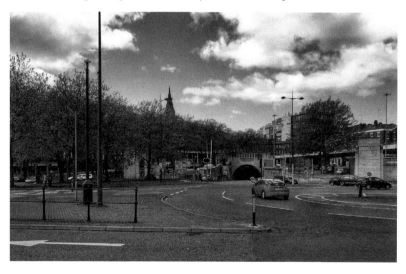

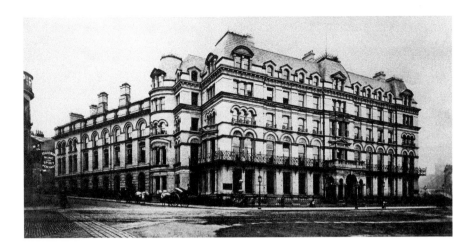

The Adelphi Hotel

The very first Adelphi hotel had opened in the early nineteenth century with the conversion of two Georgian town houses. These had been built on what was once the site of the Ranelagh pleasure gardens, believed to be the first designed provision of space for recreation in Liverpool. However, the adapted houses were not to last and a second version of the hotel was constructed in 1876. This new Adelphi had a far more luxurious atmosphere, with over 300 rooms attended to by 140 members of staff. The hotel became the leading such establishment in the region and became famous for its delicious turtle soup.

In 1912 Liverpool architect Robert Frank Atkinson was commissioned by the building's new owners, the Midland Railway Company, to design a third Adelphi. This opened on the site of the previous hotel two years later and quickly gained a reputation for being one of the most amazing hotels in the country. It was constructed in a Continental style with such size and opulence as to stand in testament to Liverpool's importance on the world stage. Today the Adelphi Hotel is part of the Britannia Group and is just one of many such establishments for visitors to frequent across the city.

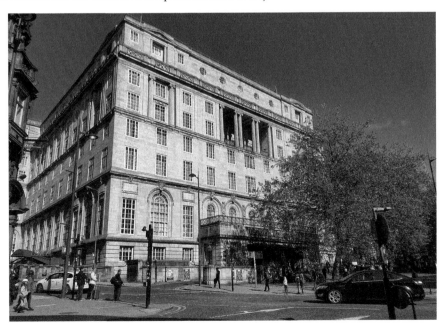

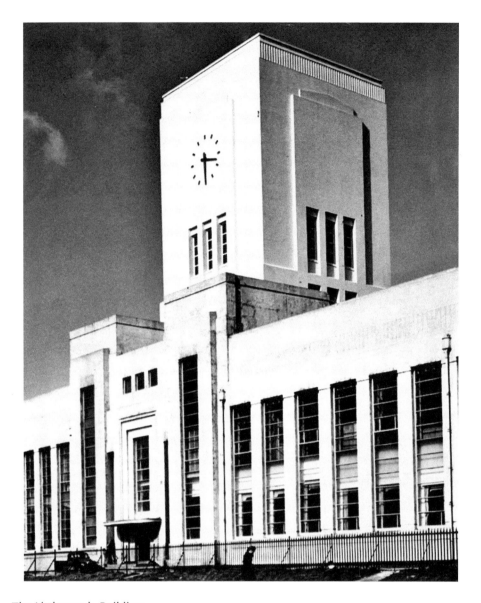

The Littlewoods Building

The Littlewoods building was the headquarters of the eponymous betting and retail enterprise established by entrepreneur John Moores in 1923. The Edge Lane building was completed in 1938, but the following year it was acquisitioned by the government to assist in the war effort. The property's large internal spaces made it the perfect location for the construction of military aircraft. Its printing presses were also commandeered to produce the thousands of National Registration forms necessary for the successful running of wartime civil service and it escaped the war unscathed.

Ownership of the building passed to the North West Regional Development Agency in 2003 but has struggled to be find a new purpose for the twenty-first century. Talk of regeneration has not yet come to fruition and when arsonists targeted the building in 2018, it was feared that the site would need to be demolished. Fortunately, the integrity of the structure was not affected and a £50 million scheme to transform the site into a television and film studio is currently underway.

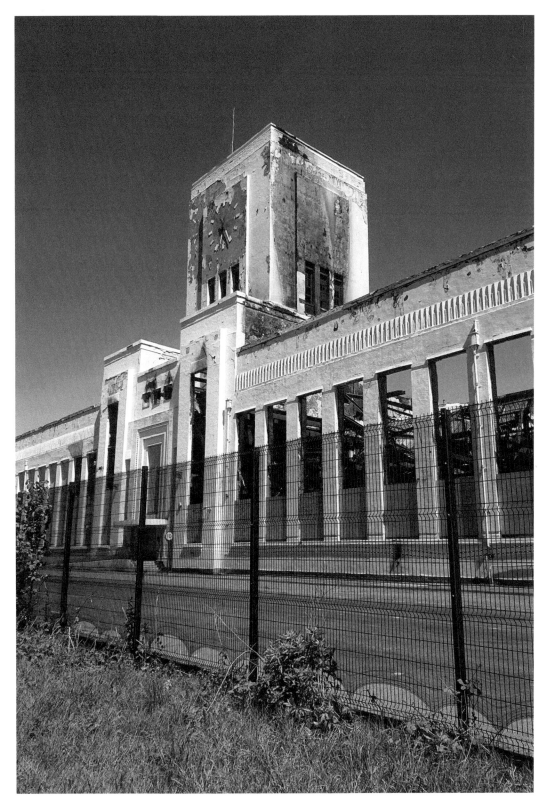

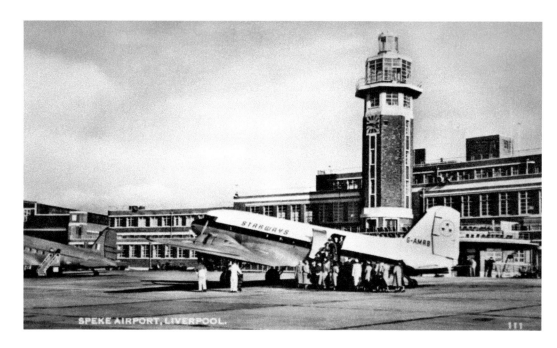

Speke Airport

The land on which the airport was built was formerly allotment gardens part of the Speke Hall estate. The main terminal was designed by E. H. Bloomfield from the City Corporation in 1939 and finished in a sleek contemporary style, with a sense of grandeur above and beyond all expectations. The Royal Air Force acquisitioned the buildings after the onset of the Second World War, with the airport returning to civil aviation in 1945 and operating for another forty years.

In the closing years of the twentieth century Liverpool's former airport was converted into an exceptionally unique hotel. The internal layout of the building has been sympathetically redesigned to provide guests with modern amenities while retaining the airport's architectural and historic significance. Flights in and out of the city now operate from new facilities at the nearby Liverpool John Lennon Airport, the first airport to be named after an individual. The new terminal opened in the 1980s and currently handles 5.1 million passengers and offers flights to over seventy destinations.

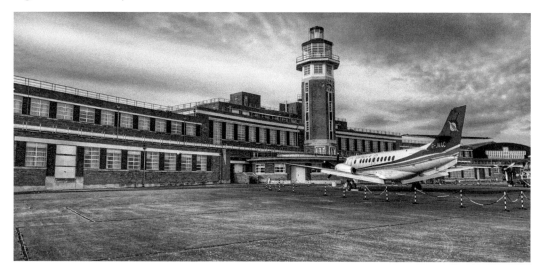

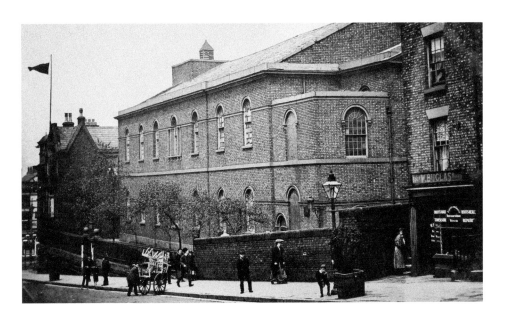

St Mark's Church

This church was constructed on the incline of Upper Duke Street and opened in 1803 with enough room for 2,400 parishioners. Its opening was marred by a gallery collapsing, which caused significant injuries. An attached steeple was also deemed dangerous early in the building's existence, rendering the church particularly unpopular in contemporaneous opinion. As the century continued the numbers of those using the church steadily declined and in 1923, after over a decade of closure, demolition works commenced.

The site was cleared for uninspiring brick warehousing and was first occupied by pickle and sauce manufacturers H. J. Heinz. From the 1930s Lewis' department store took over and utilised the vast space within for the next fifty years. Until recently the property had been home to the Hondo Chinese Supermarket, positioned opposite the city's China Town, but there are now plans to demolish the building for the construction of student accommodation.

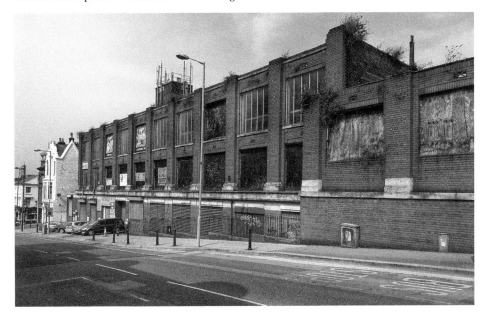

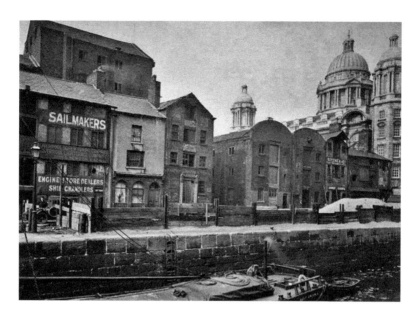

Mann Island

Mann Island was once a virtual island connected to the shore by just a slim strip of land near James Street. It is believed to have been named after John Mann, an oilstone dealer who traded in this neighbourhood in the mid-eighteenth century. Through the Victorian era numerous warehouses for the shipping industry sprang up in this convenient location at the riverside, benefiting from expedient access to Liverpool's important network of docks.

One of most spectacular transformations of recent years has seen this part of Liverpool dominated by two glass and granite-clad modern megastructures, Latituide and Longitude, joined together by a double-height glass atrium known as Equator House. The buildings, designed by the firm Broadway Maylan and completed in 2011, have been controversial additions to the cityscape with many critical of their place adjacent to the Liverpool's famous Three Graces and the UNESCO World Heritage waterfront.

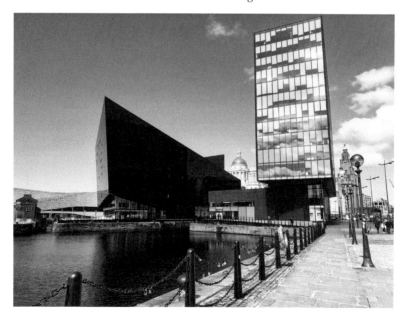

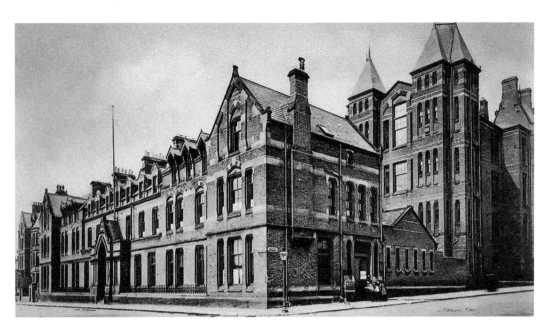

The Royal Southern Hospital

The new Southern Hospital was situated at the corner of Caryl Street and Northumberland Street and built on what had earlier been a timber yard. The building was designed by local architects Messrs Culshaw and Summers, and was formally opened by Prince Arthur, the Duke of Connaught, in 1872. The hospital could accommodate 200 beds over three tiers of wards on a pavilion plan, designed to make most of fresh air and ventilation.

The hospital closed in 1979 with the opening of the new Royal Liverpool Hospital in Prescot Street. The old Victorian buildings were demolished, and the land was prepared for the construction of new semi-detached dwellings. Despite being such a dominant building for so many years no trace of the hospital or the area's former medical connections remain.

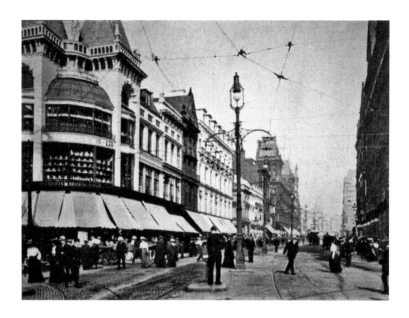

Bunneys Department Store

Local businessman Arthur Bunney appears to have established his brand at some point in the 1880s. The impressive store dominated the corner of Whitechapel and Paradise Street, with its two mighty towers overlooking shoppers below. It proudly described itself as a specialist in oriental goods and novelties, all housed within an elegant Edwardian baroque building. It was a style inspired by the work of celebrated architect Sir Christopher Wren, along with the extravagant eighteenth-century architecture of France.

The store was replaced in the 1950s by a large block that later gained fame as the location for the office of Brian Epstein, and it was here where he shrewdly signed an unknown group called the Beatles. This piece of musical history was demolished in 2012 to allow the £25 million construction of a branch of American clothing retailer Forever 21, including an enormous digital advertising screen illuminating the pedestrians of Whitechapel, Lord Street and Church Street.

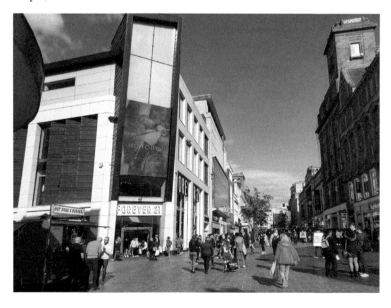

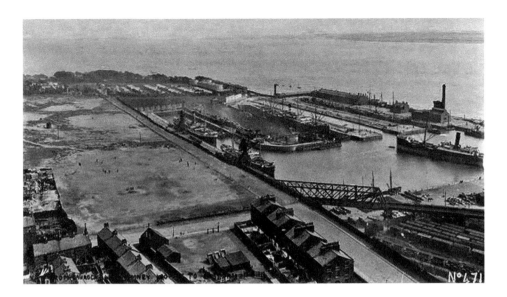

The Herculaneum Dock

Liverpool's most southerly dock takes its name from the Herculaneum Pottery Works that were based here from 1794 to 1841. The dock itself was constructed by the Mersey Docks and Harbour Board and opened in 1866. Over the years the site expanded in stages, featuring several graving docks and a coaling dock. A notable feature was the overhead railway, whose track ran through a tunnel in the nearby cliffside and onwards to Dingle.

The Herculaneum Dock closed in 1972 and the site was filled in to create a car park. In 2004 part of the site was acquired for the residential development City Quay and as part of the scheme, the old dock was dug out and transformed into a central water feature. A health and fitness centre also operates on the site but the nearby cliffside tunnel is no longer in use. However, evidence of the location's heritage can be found through the conservation of the petroleum stores built into the perimeter.

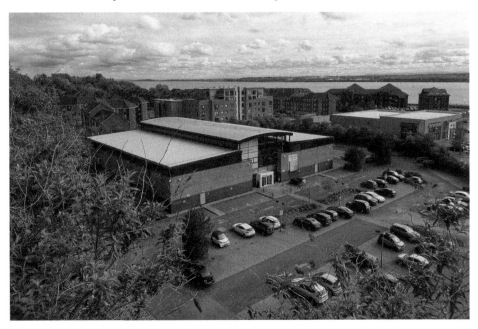

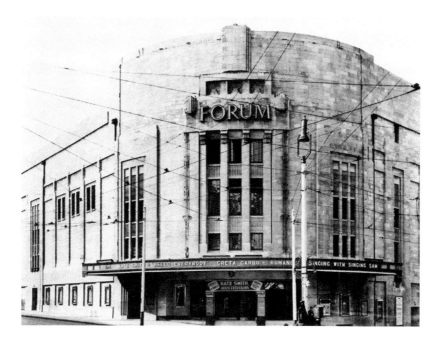

The Forum Cinema

It was on Saturday 16 May 1931 when the Forum Cinema welcomed its first cinemagoers with the film *Almost a Honeymoon*. It was a large three-storey establishment, well positioned at the junction of Lime Street and Elliot Street, finished in Portland stone, with a bronze canopy and an interior foyer lined with Italian marble. Inside was enough space for almost 2,000 ticket holders, making the Forum one of the most popular city picture houses of the time.

In the 1970s the cinema was renamed the ABC and rebranded again as the Canon the following decade. The cinema survived for almost another twenty years before closing its doors for the final time in 1988 with a special screening of *Casablanca*. Since then the building has struggled to find a purpose and proposals to suitably convert the property have so far failed to materialise.

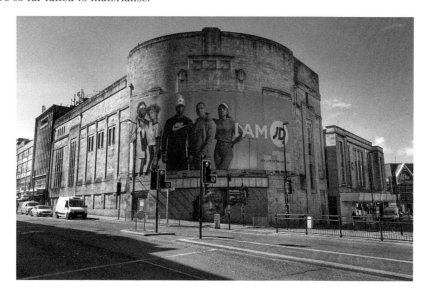

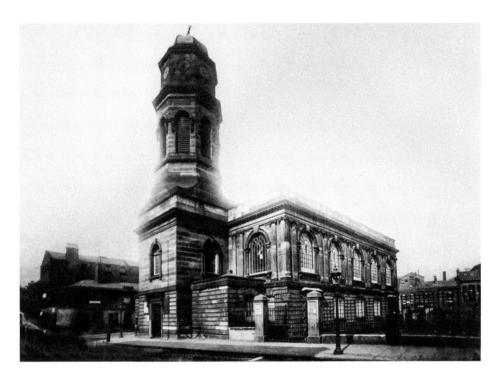

St Thomas's Church

Said to be a most remarkable and elegant church with the tallest spire of its day, St Thomas's once stood in Park Lane near to the centre of the town. It was constructed in 1750 to the classical designs of local architect and builder Henry Sephton. High winds saw the 241-foot tower collapse in 1757, causing considerable damage to the church's west galleries. Its replacement was cautiously reconstructed significantly lower and a graveyard was established in the following decade.

The end for the church came in 1905 when it was deemed no longer necessary for the spiritual needs of the local population. The site was finally cleared in 1911 and by the end of the century the land had been utilised for car parking. A landscaped memorial garden dedicated to the church was completed in 2010, highlighting the local significance of the building and the lives of many notable eighteenth- and nineteenth-century citizens whose corpses remain buried beneath the surface.

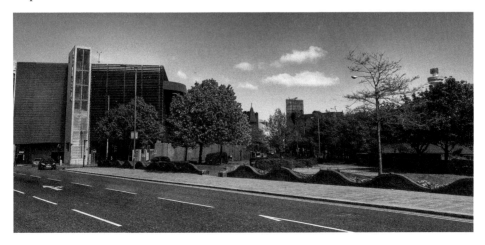

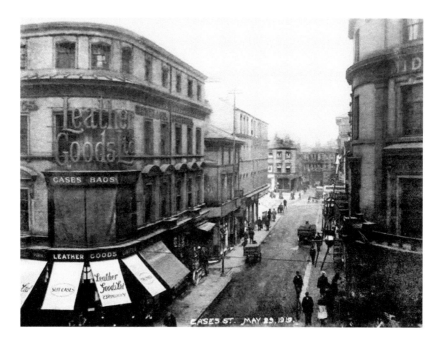

Cases Street

Cases Street takes its name from Thomas Case, the brother-in-law of wealthy heiress Sarah Clayton, who was a key player in eighteenth-century Liverpool affairs. Cases Street was lined with various commercial premises and provided an unobstructed route through to Clayton Square with Ranelagh Street. Originally its narrow offshoot passageways also connected to Church Street to the south and land used for roperies in the north.

The arrival of Clayton Square shopping centre in the 1980s saw a large portion of Cases Street knocked down. The development saw part of the street repurposed for the interior of the new complex, all situated beneath a large glazed atrium. Just a small number of older pubs and commercial units survived the transformation, but a tradional fruit and veg stall continues to trade nearby.

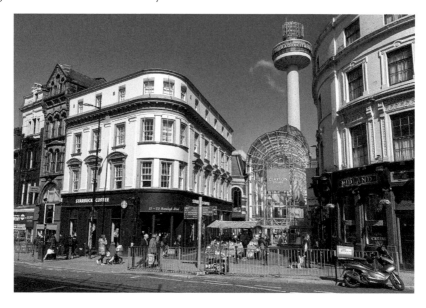

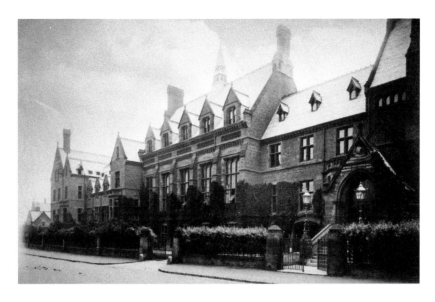

Newsham Park Seaman's Orphanage

This imposing institution was established as the Liverpool Seaman's Orphan Institution, opening in 1874. It was designed by the celebrated architect Alfred Waterhouse to offer accommodation and education to orphaned children of sailors. Many VIPs came to observe the work of the orphanage including Queen Victoria herself, who made an auspicious visit in 1886. The orphanage closed in 1949, with the property adapted into a hospital several years later by the Ministry of Health.

The building operated as a hospital until 1992 when the property served as accommodation for long-term psychiatric patients from the recently closed Rainhill Asylum. The building officially closed five years later and has remained empty ever since. The vast size of this immense property has proven problematic for new uses to be determined, but in recent years the abandoned hospital has been hired for a number of temporary events ranging from outdoor music concerts to nocturnal ghost hunts.

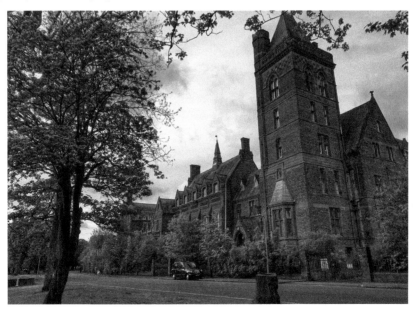

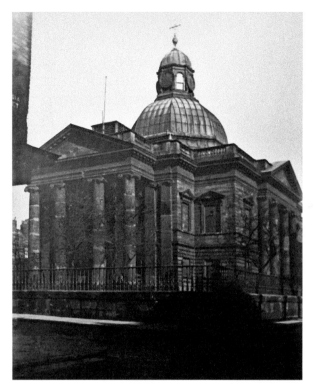

St Paul's Church

St Paul's is believed to have been designed by Timothy Lightoler and completed in 1769. It featured an impressive central dome supported by eight Ionic columns, along with galleries, an altar and moveable pews. The church had a capacity for 1,800 worshipers but suffered from acoustic problems early on. Its grand appearance was also not in unison with its relatively confined location, and St Paul's was soon overshadowed in a wilderness of warehouses and industry.

The church was closed in 1901 and purchased by the Lancashire and Yorkshire Railway Company as the site for an unfulfilled extension to Exchange station. The desolate building survived until the 1930s when it was demolished to make way for a purpose-built boxing arena, the Liverpool Stadium. This itself was knocked down the 1980s and today the site is home to a newly constructed business district known as St Paul's Square.

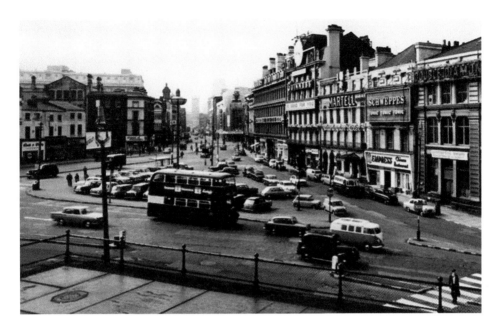

St George's Place

The mid-twentieth century saw the Victorian buildings that once stood opposite Lime Street station adorned with illuminated advertisements, lighting up this busy part of the city centre like never before. Accommodation providers such as the Washington Hotel and the Imperial Hotel were often the inn of choice for visitors disembarking from the nearby station, the latter of which boasted an enormous 'Guinness Time' clock that ticked for many years.

The curve of St George's Place was pulled down in the 1960s with the arrival of St John's Shopping Centre. The view for visitors has changed substantially as they are now greeted by Europe's largest full-motion digital screen. At almost 31 metres by 7 metres in size, it takes the place of the old pubs and hotels and provides an animated barrier to the rear of the shopping complex, its car park and a branch of the Holiday Inn hotel chain.

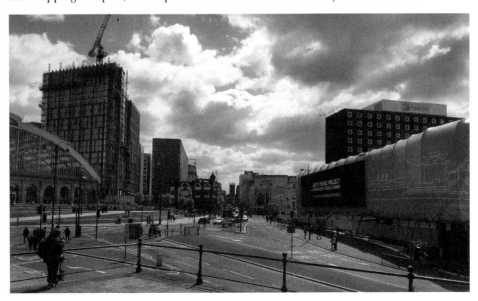

Upper Frederick Street Public Baths and Washhouse

This was the first purpose-built public baths and washhouse in Britain. Its construction in 1842 was inspired by the brave work of Liverpool's Kitty Wilkinson, who had fought against the hellish cholera epidemic that swept across the town the previous decade. Having the only boiler in the neighbourhood, Kitty had taken in the clothes and linen of her neighbours for hot cleaning and undoubtedly saved many lives in the process. She campaigned for a permanent establishment and gained the support of the authorities, who came to the recognise the importance of cleanliness in public health.

By the mid-twentieth century many of the buildings here had been cleared away in an effort to improve public health on a phenomenal scale. Whole streets were demolished, and rows of unsanitary courts and cramped terraces were replaced with cleaner, brighter and better overall housing stock. The street is now unrecognisable compared to the days of Kitty Wilkinson and is occupied by a variety of low-level modern dwellings close to the city centre.

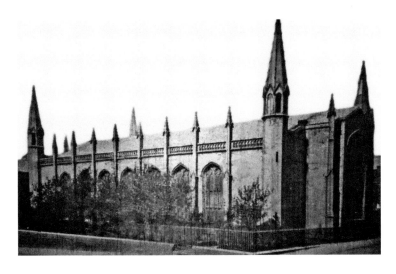

St Phillip's Church

The history of St Phillip's dates to the early years of the nineteenth century, designed by Thomas Rickman and constructed by John Cragg of the Mersey Iron Foundry. This rarely photographed church occupied a large plot on Hardman Street, set back from the road by a small graveyard surrounded by a low stone wall with iron railings. It stood to serve the wealthy residents who had set up home in the large Georgian houses in this part of town and could accommodate 1,200 people. Over time numbers through the doors began to dwindle as other churches came to be built in the surrounding area. The last service at St Phillip's took place in 1882 and the property later purchased at auction by the Salvation Army to be redeveloped as a barracks.

Plans to once again redevelop the address were implemented in 2017. By this time the property had become divided into several food outlets, with only the ground floor in use. Demolition began that winter during which several features of the former church were found encased within the later Victorian additions. These elements, however, were largely unworthy of salvage and had degraded to a substantial extent. The site is now occupied by newly built student accommodation ideally situated for the nearby universities.

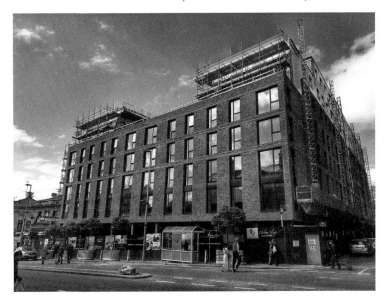

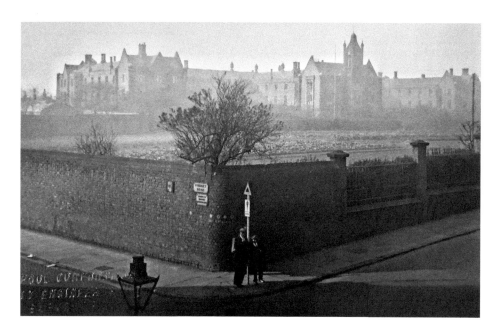

Kirkdale Industrial School

The school opened on 1 May 1850 with a raison d'être to care for and educate destitute children away from the overcrowded and unsuitable adult workhouses. The design was Elizabethan inspired and designed by the London firm of Lockwood and Allom at a cost of £32,000, a sum borne entirely by the parish. The era had seen a rise in juvenile pauperism in Liverpool and after much debate it was decided that a substantial new institution would be built to accommodate such unfortunate youngsters on land in Kirkdale, a few miles north of the town. It housed upwards of 1,000 children who were taught common skills of the day.

Children ceased to be taught here in 1904 when it became the Kirkdale Homes for the aged and infirm. In 1922 the site was taken over by the West Derby Union and, later, Liverpool City Council. In the mid-twentieth century the former industrial school was renamed Westminster House, but the site was completely cleared in the 1980s to make way for an array of new streets and housing.

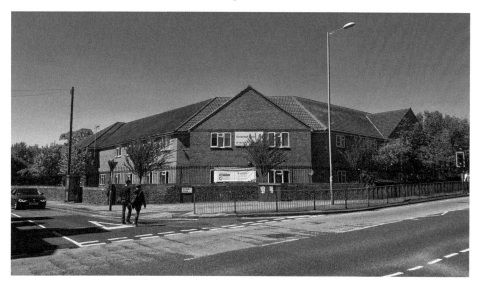

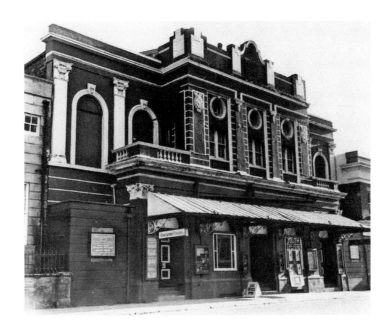

The Everyman Theatre

The Everyman Theatre was founded in 1964 in what had originally been Hope Hall, a brick chapel built in 1837 and later converted for use as a cinema. Throughout the 1960s the building found favour with local creatives and became a meeting place for poets, musicians, sculptors and others involved in Liverpool's art scene. This bohemian atmosphere resulted in the opening of the Everyman Theatre, and the building was redesigned the following decade along with the installation of a new brutalist-style façade.

The building was demolished in 2011 and completely rebuilt to the award-winning designs of Haworth and Tompkins, which saw many of the old bricks recycled into the fabric of the new structure. The theatre can now seat 400 patrons in its thrust staged auditorium and includes a bar and bistro, rehearsal space and offices. The theatre's frontage has also been transformed and today features over 100 aluminium panels portraying actual Liverpool residents. In 2014, the Everyman won the Royal Institute of British Architect's Stirling Prize for best new building.

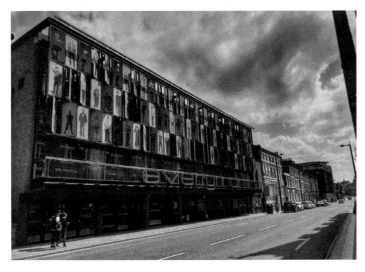

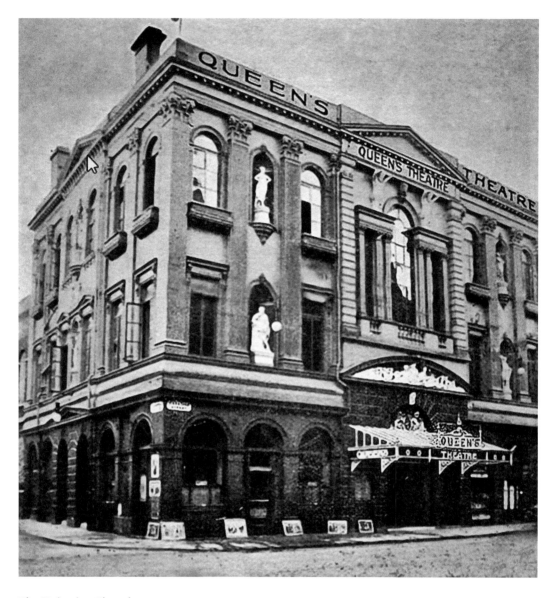

The Unitarian Chapel

The Unitarian Chapel opened at the corner of School Lane and Paradise Street in 1791. It was constructed in an elegant octagonal form with dual windows positioned across each elevation, and a large roof lantern positioned at its centre along with a towering cupola. The façade was decorated with imposing classical columns beneath an opulent pediment, adorned with decorative stone urns positioned across the balustrade. Parishioners continued to worship here until 1849, at which time a new church was established in Hope Street, away from the hustle and bustle of the town's commercial centre.

The Royal Colosseum Theatre and Music Hall took over the building the following year and under various names entertained the populous for over fifty years. In 1916 the property was put to use as a warehouse but ultimately destroyed during the war. Today the site lies within the Liverpool ONE development and is occupied by a huge modern block of retail units with residential apartments situated above.

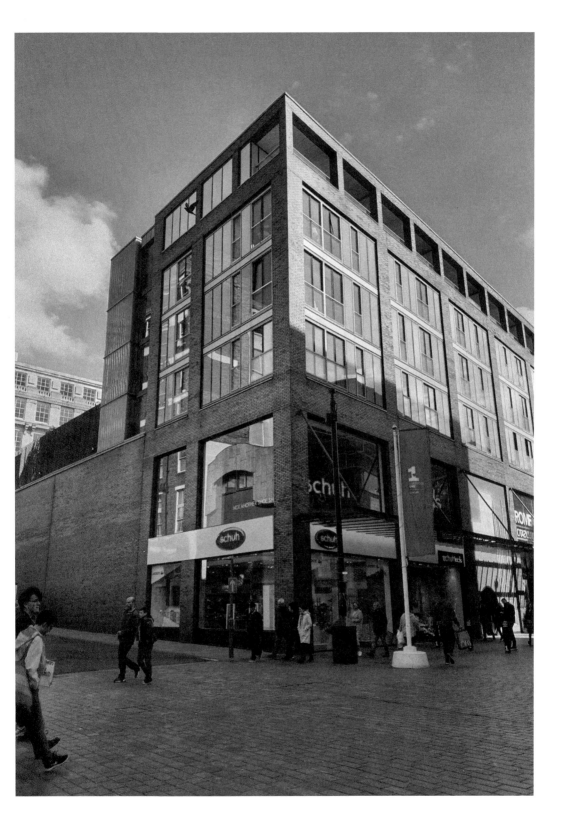

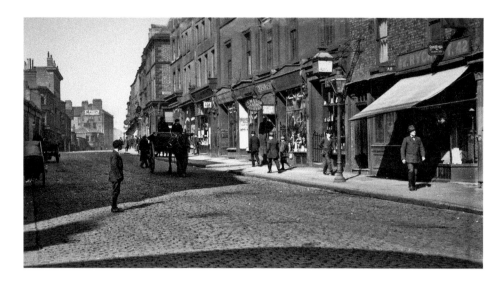

Old Hall Street

This street is believed to have taken its name from the former mansion of the Moore family, who lived here in the thirteenth century. The street later grew to become a busy carriageway lined with shops and businesses. One of its most important buildings, St Paul's Eye Hospital, opened in 1912. It had originally been established at an address in Mount Pleasant thirty years earlier and operated as a specialist private charity to provide relief to the poor.

All but a few historic buildings on this street have been replaced in recent decades with modern office space. The site of the old hospital, however, is now occupied by a public sculpture called *Connections – Face of Liverpool*, designed in 2006 by local artist Stephen Broadbent. It represents the city's position as a place of national and international trade both past and present. The Beetham Tower stands alongside, which was completed in 2004 and has twenty-nine floors of apartments that overlook much of the neighbourhood.

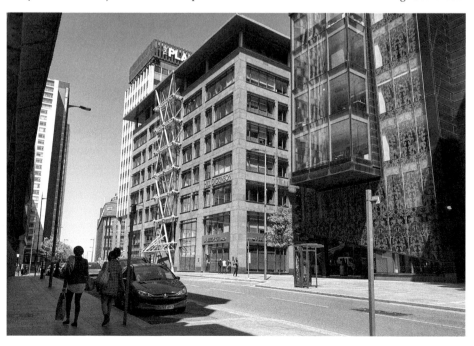

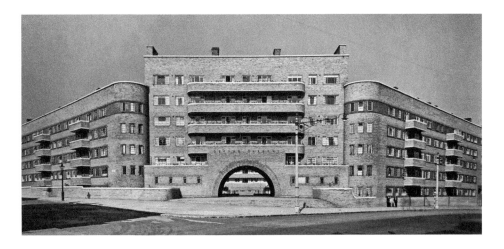

Gerard Gardens

Gerard Gardens came to occupy a part of the city that had previously featured a collection of Victorian courts and unsanitary slum housing. Its development was part of a nationwide drive in the 1930s to eradicate the poor housing conditions of the past, with Liverpool's Director of Housing Lancelot Keay, charged with leading the transformation locally. His efforts saw the creation of 30,000 new dwellings across the city, including Gerard Gardens, a medium-rise block influenced by similar designs in Vienna. Many of its residents experienced the luxury of indoor bathrooms, hot and cold running water and electricity for the very first time.

The innovative flat complex was demolished in 1987, having fallen into a less than desirable condition, and the neighbourhood was later transformed with the construction of new semi-detached dwellings, complete with private gardens. Despite the loss of the old flats, the heritage of the neighbourhood has been remembered with the naming of Gerard Street within the neighbourhood's more recent streetscape.

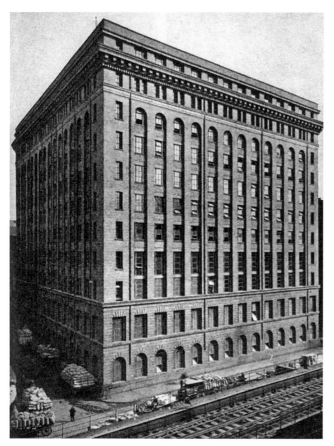

Bibby's Mills

A gigantic mill complex once stood in Waterloo Road. Positioned between the Waterloo Dock and the Great Howard Street goods station, it was commissioned by the firm of J. Bibby & Sons, who specialised in seed crushing, seed extracting, oil refining and the manufacturing of compound cooking fats. The site was considered to be the best located works of their time with an output of 1,000 tons a day. Its warehouse bore an appearance reminiscent of construction seen across the Atlantic when it was completed in the early twentieth century.

By the end of the century the buildings had outlived their usefulness and were demolished. The site has been occupied by the property of major wholesaler Costco, which was competed in 1995 along with car parking. Evidence of the location's industrial past is still apparent with the survival of the nearby Waterloo Warehouse and the impressive brick dock wall, which remains in situ along much of the street.

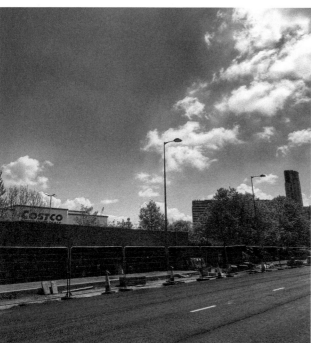

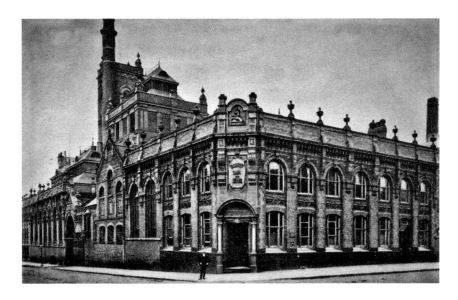

Cain's Brewery

Robert Cain was born in County Cork in 1826 and arrived in Liverpool as a merchant seaman. By 1850 he had married and settled down to life as a brewer, operating from a mediocre site in Limekiln Lane. The business, however, went from strength to strength and Cain was able to purchase several pubs and expand their trade to meet the demand of the masses. In 1858 he acquired Hindley's Brewery on Stanhope Street and set about developing and improving the site. Soon Robert Cain & Sons was a household name and its founder one of the wealthiest and most powerful men in the city.

Cain's Brewery has experienced a resurgence in recent times and is now a popular focal point with pop-up bars, independent retailers and various eateries trading from here. Its life as a working brewery ended in 2013 after succumbing to financial pressure, but its new status as an extensive brewery village has trigged a genuine renaissance for this site. Plans for future development are in motion but it remains to be seen if beer will ever again be brewed from this historic address.

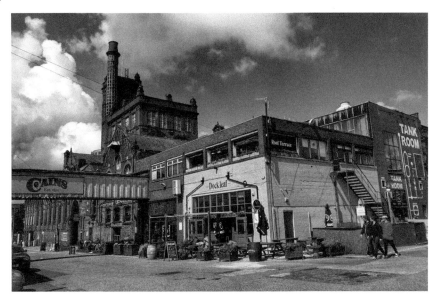

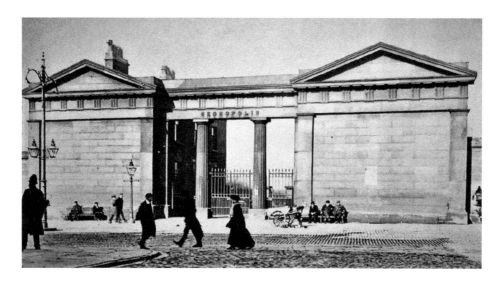

The Necropolis

The Necropolis opened in 1825 as a large cemetery on the outskirts of the town. It covered approximately 5 acres and was contained within a 13-foot-high stone perimeter wall with access from West Derby Road. The home of the registrar and the chapel within was constructed in a classical Greek style by John Foster Jr with sturdy Doric columns positioned at its entrance. By the time of its closure in 1896, it is estimated some 80,000 bodies had been interred within its grounds.

Unsanitary conditions forced a stop to new burials and the closure of the cemetery in 1898. In 1914 the site was revitalised and landscaped as Grant Gardens, opened by city alderman J. R. Grant. The cemetery has lost much of its historic architecture over the years, but the thousands of bodies laid to rest here were never exhumed. Today the gardens serve as a pleasant public park and playground.

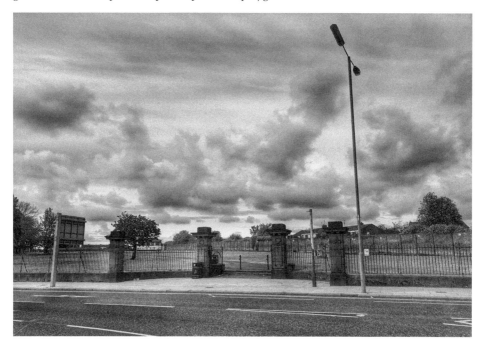

Mason Street

Mason Street is situated in the Edge Hill suburb of Liverpool and was an area favoured by wealthier residents who enjoyed an escape from the commotion of life in the centre of town. One such resident was Joseph Williamson, who was responsible for many of the housing projects in the neighbourhood and who also commissioned the labyrinth of underground tunnels that lie beneath the surface. The street is believed to be named after Edward Mason, a timber merchant who lived and traded from a large and extensive property here in the mid-eighteenth century.

The character of this neighbourhood has changed substantially, with many of the older and distinctive town houses demolished to make room for the path of the railway and other less genteel developments. Today the street consists of comparably modern housing and gap sites, but now stands adjacent to the new Paddington Village development which hopes to attract a range of new scientific businesses. The old tunnels serve as a tourist attraction and continue to be dug out by a team of dedicated volunteers.

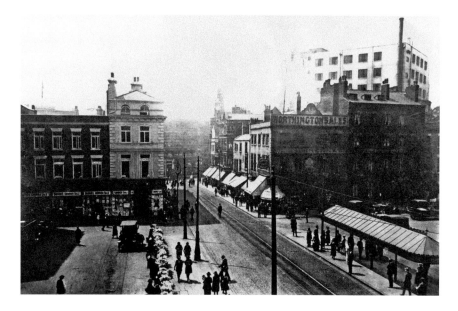

Clayton Square

The daughter of a wealthy MP, Sarah Clayton used her fortune and position to form and lay out Clayton Square in the mid-eighteenth century in what was an early attempt at formal town planning. This area has undergone numerous periods of change throughout years, with each generation influencing its appearance and design.

Any historic remnants of the Georgian square have been lost, as have any later Victorian embellishments, with the introduction of modern commercial units and the eponymous Clayton Square Shopping Centre. The square is still legible but is now dominated by twentieth-century construction and can often be found bustling with people passing through this busy part of the city.

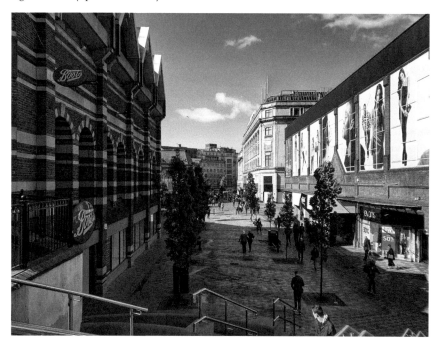

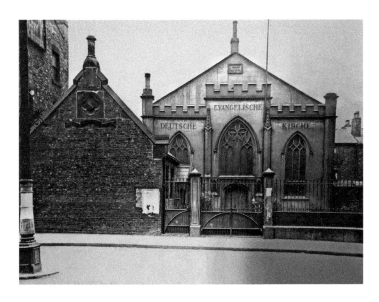

The German Church

This quaint structure was constructed in 1777 and was originally known as the Newington Chapel. In those days the land here was distinctly verdant, with open fields to be found in all directions. The church's origins lay in disagreements between worshippers over the appointment of a preacher at the Ancient Chapel of Toxteth. That year a breakaway congregation commissioned a new place of worship in Renshaw Street, which by 1820 had been enlarged to seat 380 and finished with a Gothic façade. In 1871 the church was sold to a consortium of German merchants in the town and repurposed as the German Evangelical Church.

The property later served as a warehouse and motor garage, but by the 1960s the old church had been demolished. The plot is now dominated by a towering block of student accommodation known as the Ascent. This twelve-storey structure contains 192 apartments and opened in 2017. It is another development targeted at the city's burgeoning population of scholars, a market that has seen Liverpool's city centre grow exponentially over the past decade.

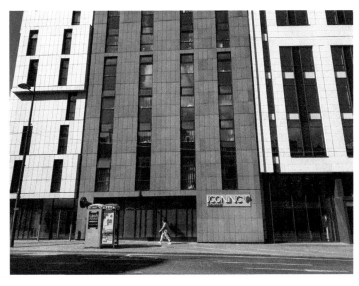

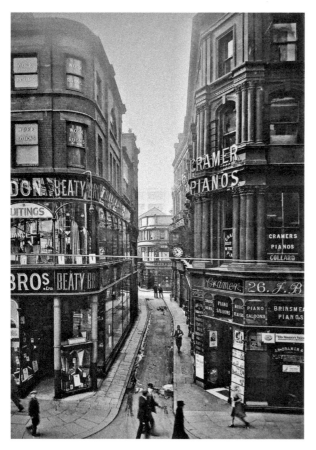

Old Post Office Place

This winding passageway once connected Church Street with School Lane, while also providing access to Brooks Alley. The route dates from Georgian times and takes its name from the post office that relocated here from North John Street in 1800. By the mid-Victorian era substantial commercial buildings had been erected here, each fitted with large plate glass windows to allow the convenient perusal of goods.

The vista down Old Post Office Place is almost unrecognisable thanks to the construction of Spinney House in 1955. This was built for the Littlewoods retail empire, which ceased its high street presence in 2006 after eighty-three years of trade. This building, now operating as a branch of the clothing store Primark, cut the old lane in half, with only the Old Post Office pub, situated at the rear of the building, remaining from those earlier times.

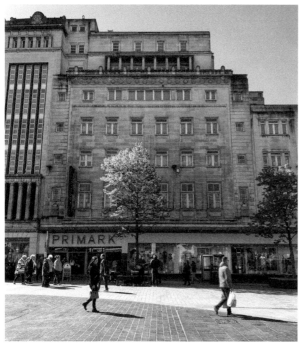

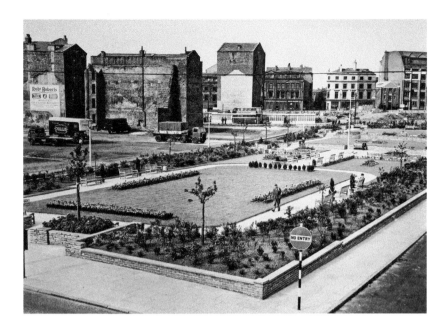

Coronation Gardens

The Second World War brought widespread devastation to many parts of the city centre including Paradise Street, which saw many of its Victorian buildings rendered to a mass of ruins. With the war over, the 1950s saw the crowning of Elizabeth II and the planting of Liverpool's Coronation Gardens. This pleasant landscaping scheme was officially opened by the leader of the council, Sir Alfred Shennan, in the summer of 1953. The gardens stretched from Paradise Street to South John Street and offered members of the public a spot of greenery in what was still very much a war-ravaged setting.

The gardens bloomed for just a generation, with the site given over for a bus station and multistorey car park in the 1960s. Nowadays it is home to retail units within the Liverpool ONE development. As part of this multimillion-pound scheme, 5 acres of open land near to the site of the old gardens was landscaped into what is now known as Chavasse Park, providing much-needed inner-city greenspace.

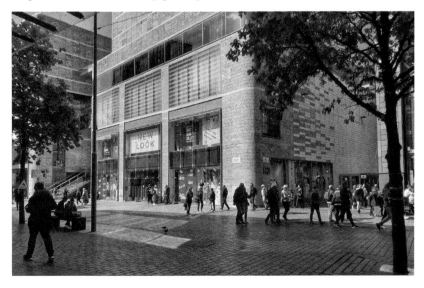

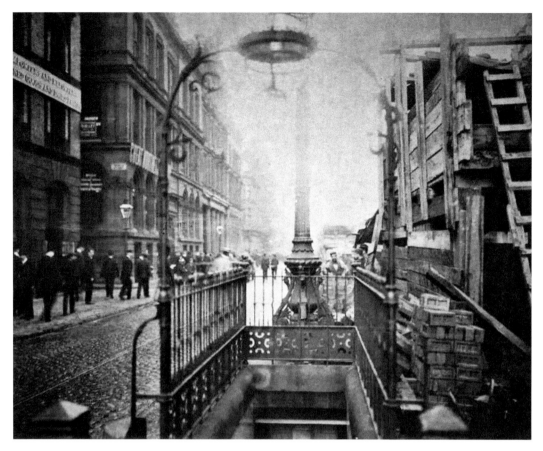

Victoria Street

Victoria Street was not laid out until the mid-nineteenth century. Until then the land here was occupied by a much smaller road called Temple Court, which cut its passage behind the once unbroken terraces of Stanley Street. One of Victoria street's most notable features was a set of underground public conveniences, which stood here for much of the twentieth century. They were eventually covered and tarmacked to provide an additional lane for the city centre's increasing levels of road traffic.

The road remains a busy main route through Liverpool, with little change since the additional lane was laid down. Nowadays the old warehouses that once lined the street have been converted into bars, clubs and restaurants making the most of their advantageous position near to the popular nightspot of Mathew Street.

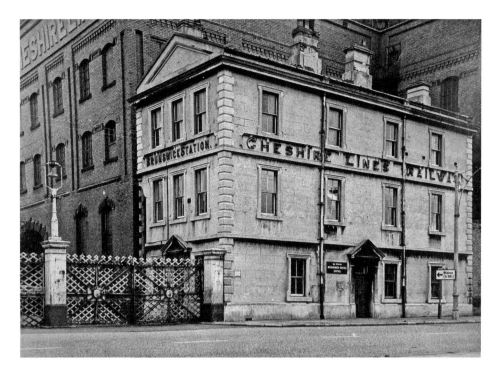

Brunswick Railway Station

Sefton Street's Brunswick railway station began operating in 1864. It was built as a terminus for travellers to the town centre by the Garston and Liverpool Railway Company, but its poor proximity from the town centre saw the station close after just ten years when a new route was established direct to Liverpool Central. The station was repurposed as an extensive goods depot, making use of the substantial brick-built warehouse that stood alongside.

Brunswick station reappeared on the local network in 1998 with the opening of a new station, just yards from the old, which had been demolished the previous decade. The site of the former Victorian railway station is now home to a car dealership dating from early twenty-first century, with little surviving perceptible evidence of the location's railway heritage left in situ.

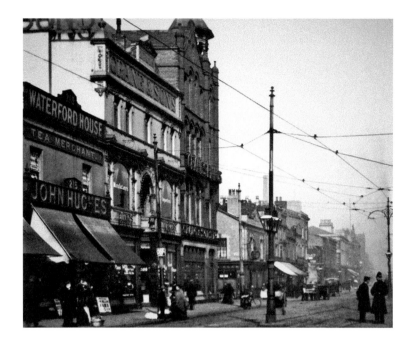

Scotland Road

This road was once the main route out of town to the north and was one of the poorest and most animated parts of Victorian Liverpool. Many of the inhabitants who dwelt in and around these parts had escaped the dreaded Irish famine of the 1840s. Their arrival into Liverpool boosted the population considerably and within ten years the Irish would form 22 per cent of the town's population. Many settled in Scotland Road and the area quickly become flanked by terraces of working-class residences, with various purveyors and public houses setting up in abundance.

Many of the properties throughout this impoverished neighbourhood were demolished during widespread slum clearance programmes of the mid-twentieth century when thousands of families were relocated out to the city suburbs. Today Scotland Road has become an exceptionally busy dual carriageway. Just a handful of the old public houses have remained in business, and there are now very few residential dwellings to be found here.

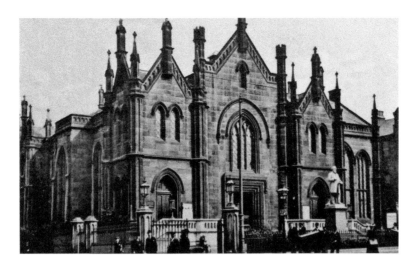

Myrtle Street Baptist Chapel

Dating from the mid-nineteenth century, this chapel was formed by members who had previously worshipped at a smaller chapel at the junction of Lime Street and Elliott Street. By 1844 the congregation had grown to warrant a new building to be constructed in Myrtle Street and the old building was demolished as part of a highway improvement scheme. The new construction was designed by local architect W. H. Gee in a Gothic style with a series of ornamental turrets positioned across each of its stone elevations. It was built to accommodate 1,000 souls, many of whom came to hear the words of the enigmatic minister Revd Hugh Stowell Brown, whose influence was so great that a memorial statue was erected by public subscription upon his death in 1884.

The church was put on the market in 1939 after almost a century of worship and demolition began the following year. The statue of Revd Brown stood boxed within a wooden case and later removed to Princes Park and finally to the grounds of Croxteth Hall where it fell into a state of decay. Today this city centre corner is home to mixed-use student accommodation, bars and eateries, but in 2015 the historic marble statue was sensitively restored and returned near to its orginal home outside where the former Baptist Chapel once stood.

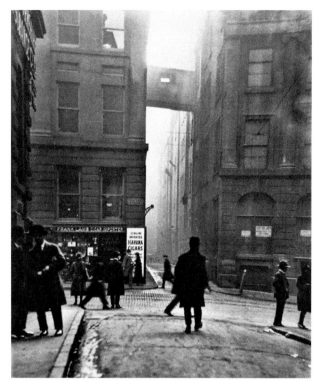

Chorley Street

This narrow passageway was first recorded as Entwhistle Street in the early eighteenth century, and at that time ran from Water Street through to a turning into what was Phenwick Alley. By the end of the century the road had been divided with the arrival of Brunswick Street, and through the years the street declined in importance, becoming a mere back alley for the warehouses built here in the 1800s. The end of Chorley Street finally came in 1924 with a bold new commission for India Buildings. This mammoth construction, designed by Arnold Thornely and Herbert Rowse, was built over the old street, but their plans did incorporate a ground-floor retail arcade to mirror the route of the lost street.

India Buildings is now highly regarded as one of the country's most significant interwar constructions, but a section was partially destroyed by the actions of the Luftwaffe. Fortunately, the damage was carefully restored under the guidance of the building's original architect, Herbert Rowse. The building has recently been leased by HMRC and will house 3,500 staff across ten floors. However, this will see the end of public access to Holt's arcade and the relocation of existing retailers to other locations around the city.

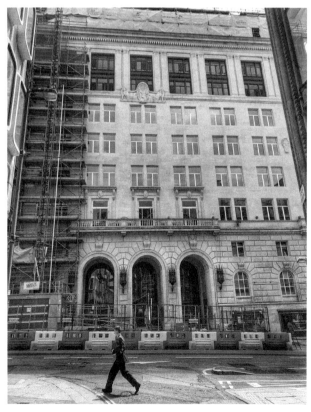

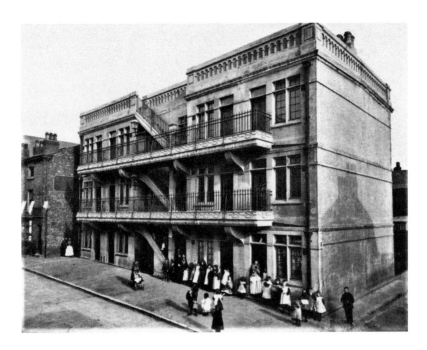

Eldon Street

In the nineteenth century the need for fast and affordable housing was a major problem for growing populations across the world, and Liverpool was no exception. Local engineer John Alexander Broadie put forward a method of prefabricated concrete panels ready to be assembled on site. This would greatly reduce the need for specialist trades but did rely on economies of scale. These innovative and pioneering dwellings in Eldon Street were ready for families by 1905 and represented an important and early attempt to solve a housing crisis through means of mass production.

The pioneering precast buildings were demolished in the 1960s and only the Church of Our Lady of Reconciliation and the aged Glass House pub remain from those earlier days. Eldon Street of the twenty-first century features more familiar housing styles, with only a small number of recently built semi-detached residences now to be found here. The plot on which Brodie's experimental housing formerly stood awaits future development.

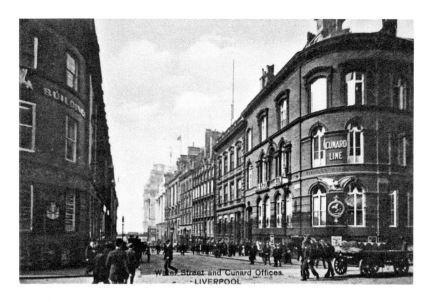

Water Street and Cunard Offices. LIVERPOOL

The Cunard Offices

The famous shipping line of Cunard opened its first office in Water Street in 1839, moving to larger offices just a few doors up in 1857 as the business expanded. It was from here, Middleton Building, that the activities of one of the world's largest shipping firms were managed. Cunard was established by Canadian businessman Samuel Cunard in 1840 as the British and North American Royal Mail Steam Packet Company. Its regular transatlantic crossing gained a reputation for comfort and reliability but faced stiff competition from its chief commercial rivals, the White Star Line.

In 1917 the business moved once again but this time to purpose-built headquarters overlooking the River Mersey. This was the Cunard Building and would become home to this thriving company for over fifty years. The old Water Street address was later occupied by a branch of Barclays Bank, but the distinctive building seen today dates from the 1970s and has recently been converted into apartments.

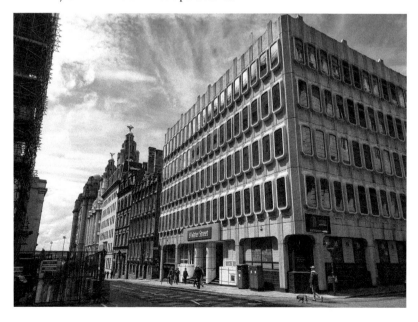

Walton Gaol

This substantial prison was completed in 1855 to plans drawn up by John Wightman, who had been commissioned to replace Liverpool's aging eighteenth-century gaol, which was no longer fit for purpose. Built in Hornby Road, the new institution contained over 1,000 cells for segregated male and female prisoners and featured two imposing Norman gate towers at its entrance. The gaol became infamous for its use of force-feeding during the early twentieth century. Hunger-striking suffragettes, including Lady Constance Lytton, brought national attention to this controversial and dangerous practice and wrote extensively of their time behind bars.

The gaol is now known as HMP Liverpool and has been designated as a Category B male prison. It covers 22 acres, has eight wings and has an operational capacity of 1,300 inmates. The building received a direct hit during the Blitz, partially demolishing a wing of the prison and killing twenty-two prisoners. It took another ten years for the final remnants of rubble to be cleared, at which point the crushed remains of a long-lost inmate were finally discovered. In more recent times a large perimeter security wall has been erected around the prison, hiding much of this feared establishment from public view.

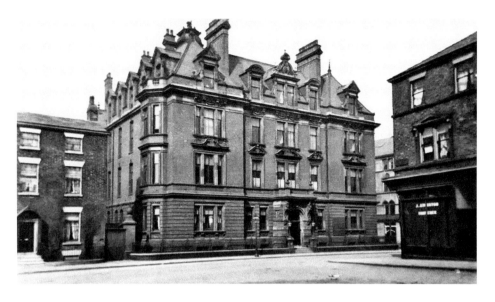

The Hahnemann Hospital

The Hahnemann Hospital was constructed and fitted out by a generous benefactor, sugar merchant Henry Tate, as a gift to the city. It opened in 1887, specialised in homeopathic treatment and was the first hospital in the country to benefit from hydraulic lifts, in addition to ventilation systems based on those promoted by Florence Nightingale. The building was designed by architects F. & G. Holme and operated as a regular hospital but acted according to the Laws of Similars proposed by the controversial founder of homeopathy, Samuel Hahnemann.

The hospital became part of the National Health Service in 1948, treating its last patients in 1976. Later its former wards were repurposed by Liverpool John Moores University for the teaching of art and design. However, the building has recently been adapted into accommodation for students of the university, featuring almost 100 apartments, along with a large communal lounge, study area and cinema room.

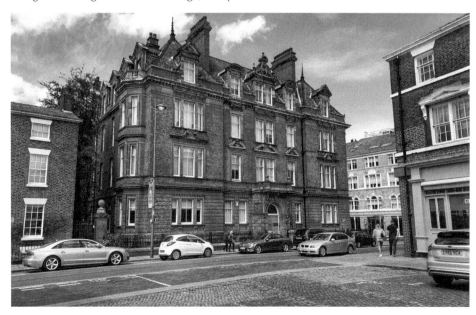

The Central Fire Station

City surveyor Thomas Shelmerdine was tasked with designing the city's new central fire station, which was completed in 1898. It was created in a remarkable Jacobean style in red brick with stone dressings and multiple engine spaces. The protection of Liverpool's populace was originally handled by a combined police and fire force, which was first established in 1836. Over the years the need for dedicated services resulted in the formation of the National Fire Service in 1941, and later the creation of dedicated local units such as the Liverpool Fire Brigade.

Staff moved out of the building in the 1970s and it was later converted into a garage. In recent years the site has been adapted to a ninety-six-room hostel, an act that has allowed the decommissioned station to find a new purpose for the modern era. The building's firefighting history is clearly legible through its architecture, with its large appliance bays and all-seeing watch tower remaining in situ.

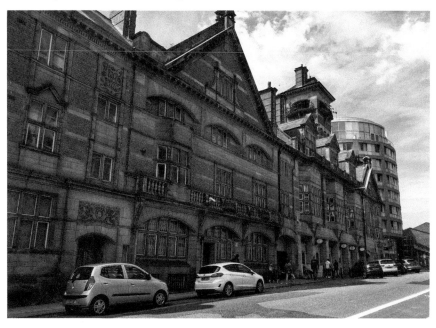

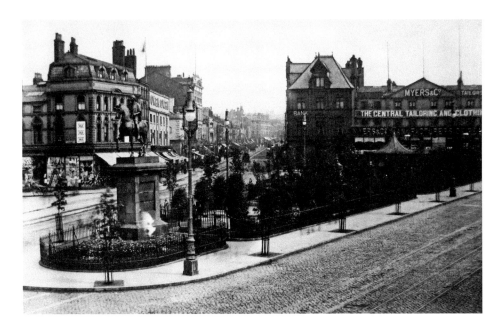

Monument Place

For generations a key feature of London Road has been the bronze statue of George III that stands upon a plinth in Monument Place. It was designed in 1822 by one of Britain's leading sculptors, Richard Westmacott, and was completed in the style of a Roman emperor sat high upon a horse in antiquated fashion. It added a touch of nobility to the busy commercial character of the locality and came to stand proudly among an assortment of shops and famous outlets, such as Owen Owen and Woolworths.

The majestic figure has sat unchanged for almost two centuries, but its setting has altered dramatically. At the corner of Stafford Street the impressive Audley House, complete with octagonal turrets and decorative gables, has been home to T. J. Hughes since 1925, while the neighbouring Victorian property, once housing the tailors Myers & Co., was demolished to make way for a series of modern commercial units with residential space above.

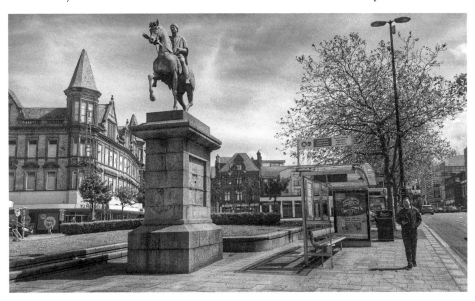

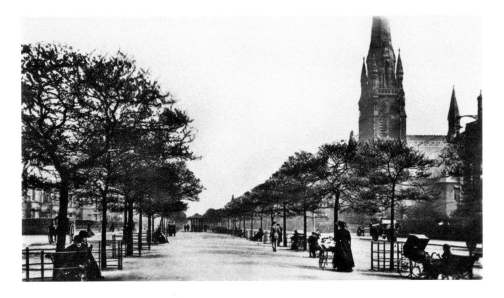

Princes Road

This wide tree-lined boulevard was originally formed in the 1840s and serves as a clear example of large-scale Victorian town planning. The road came to be filled with large and architecturally impressive three-storey properties and the homes of middle-class families. The Welsh Presbyterian Church opened here in 1867 to the designs of brothers W. & G. Audsley and, at a height of 200 feet, was once the tallest building in Liverpool.

Over time the character of this neighbourhood declined, with many of the grand residences now operating as houses of multiple occupation, with others lost from the streetscape entirely. The record-breaking church closed in the final years of the twentieth century and currently stands derelict and in need of restoration. Today Princes Road is predominantly a traffic hub connecting Toxteth to the city's Georgian Quarter, with the leafy boulevard rarely used for genteel recreation as originally envisaged.

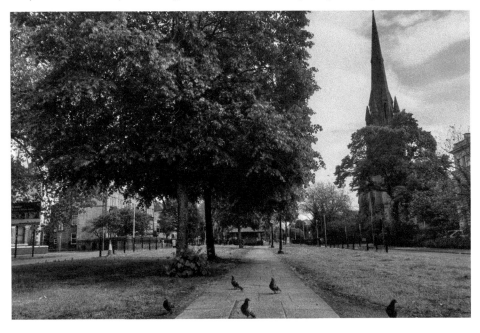

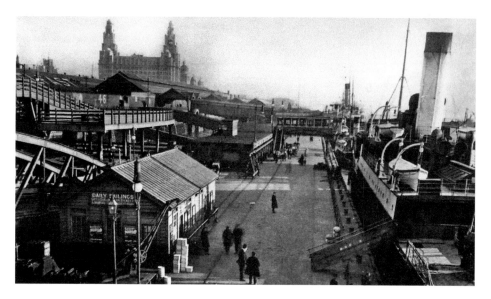

The Pier Head

Landing stages were established along the edge of the Mersey in the 1850s, continuing Liverpool's long association with the river and boosting its importance to the local economy. Over time these landing stages were joined together and extended, allowing increased traffic to and from the water's edge. The Pier Head would be the first sight for many arriving in Liverpool onboard the various transatlantic liners that regularly docked here and the last view of home for millions of emigrants leaving Britain for a new life abroad.

The historic infrastructure of old has been swept away and today the Pier Head is famous as the home of the Cunard Building, the Port of Liverpool Building and the Royal Liver Building. These early twentieth-century structures are collectively known as the Three Graces and are seen by thousands onboard the array of cruise ships that now dock at the waterfront to experience everything that Liverpool has to offer. The Liverpool Cruise Terminal officially opened here in 2007 and has helped cement the city's status as a unique and unmissable destination right across the globe.

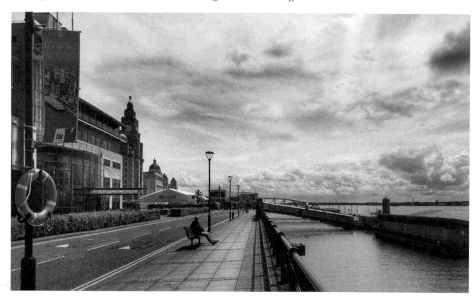